Spells for eternity

The Ancient Egyptian Book of the Dead

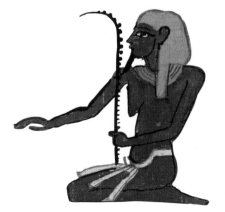

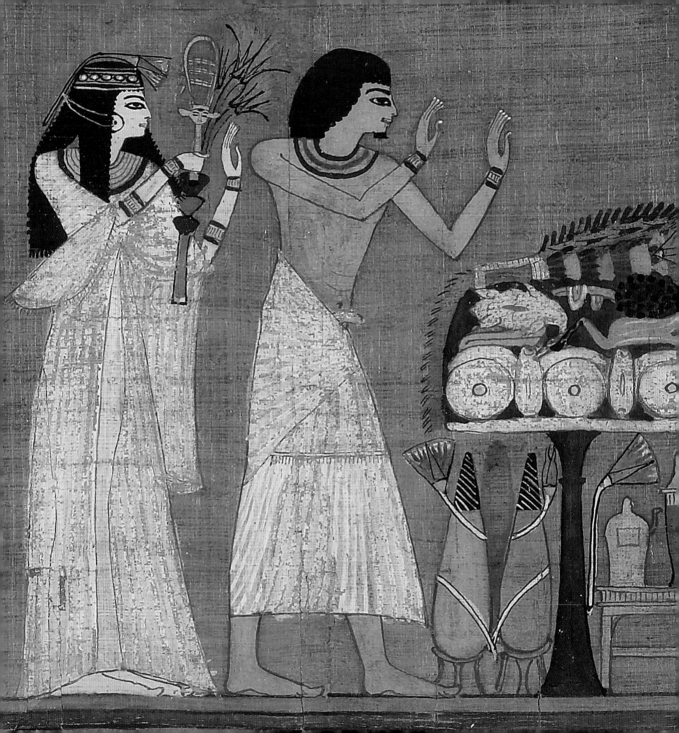

Spells for eternity

The Ancient Egyptian Book of the Dead

John H. Taylor

THE BRITISH MUSEUM PRESS

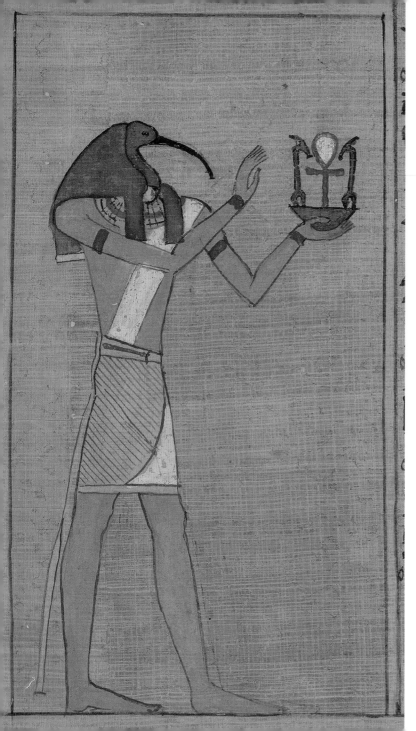

John H. Taylor has asserted his moral right to be identified as the author of this work.

First published in 2010 by The British Museum Press
A division of The British Museum Company Ltd
38 Russell Square, London WC1B 3QQ

www.britishmuseum.org

A catalogue record for this book is available from the British Library

ISBN 978-0-7141-1990-8

Designed by Price Watkins

Printed in Italy by Printer Trento

Except for the papyrus of Nebqed illustrated on p. 23 (Musée du Louvre, Paris, N3068; photo. Christian Larrieu), all the papyri and objects featured in this book are from the collections of the British Museum (photo. © The Trustees of the British Museum). Their museum registration numbers are listed on p. 128.

Frontispiece: Bakenmut and his wife worship Osiris. Papyrus of Bakenmut.
Left: The god Thoth offers an emblem of life and dominion. Papyrus of Hunefer.

Papers used in this book are natural, recyclable products made from wood grown in sustainable forests. The manufacturing processes conform to the environmental regulations of the country of origin.

FSC
MIX
Paper from responsible sources
FSC® C015829
www.fsc.org

Contents

Introduction

THE ancient Egyptians lived in a land which was fertilized every year by the flooding of the River Nile and protected from invasion by inhospitable deserts. In this favourable environment one of the most advanced and sophisticated early societies flourished for over 3000 years. Although life for most Egyptians was short (usually less than thirty-five years), they fervently wished for it to be longer. They believed that at death a person passed from the land of the living into another realm where life would be renewed and would continue for ever. So strong was the belief in this afterlife that it left an indelible mark on their material culture; enormous resources of time, thought, manpower and materials were dedicated to easing the passage across the threshold of death.

To achieve this transition meant entering regions of the cosmos which were not accessible to the living, places where only the gods and the transfigured dead could go: the sky-realm in which the sun god Ra travelled and the Netherworld, or Duat, where the god Osiris ruled as king of the dead. Through a closer relationship with these powerful deities the deceased hoped to attain the immortal status which they enjoyed.

An unopened papyrus roll.

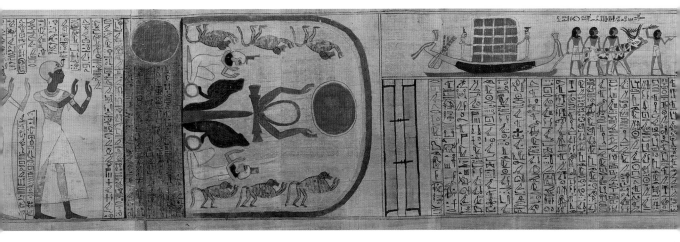

Certain formalities had to be observed at death. The corpse had to be preserved and transformed through mummification and it had to be disposed of in a correct manner, in a place both secure and identifiable so that family members could care for the spirits of their relatives. Magic played a key part in the process of transition. Moving beyond death was perceived as analogous to the hazardous and mysterious process of birth, and existence in the beyond could be fraught with as many challenges and dangers as were met with in everyday life. Just as magic was regularly used to protect and help in childbirth, sickness, injury and loss, so it was needed to face the still greater challenges of making one's way safely through an unfamiliar realm.

Magic (*heka*) could be invoked by speaking prescribed words (the Egyptian word for a spell means literally 'utterance'), by performing ritual acts and by using images which were believed to serve as receptacles for supernatural power. Speaking the words of a spell was believed to be a creative act which caused whatever was desired to happen. The same magical potential was also contained in the written word. When inscribed on the walls of a tomb or on an object placed inside it, the words perpetuated the magical effect of a spell, or gave the dead

Images and texts from the papyrus of Nodjmet.

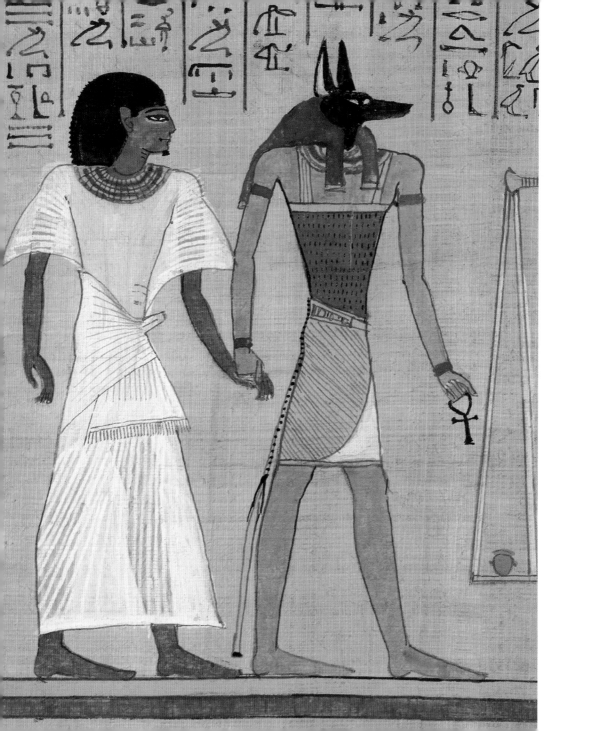

the means to use the magic for themselves. These latter texts made the dead the masters of their own destiny, freeing them from total dependency on the living to keep their spirits alive.

The placing of such magical texts in the tombs began in Egypt about 2350 BC. The oldest collection, the Pyramid Texts, was reserved for the king, but by 2000 BC the spells had become more widely available and the next major group, the Coffin Texts, are known mainly from the burials of non-royal persons of high status. This evolutionary process culminated in the collection of spells now known as the Book of the Dead, which first emerged about the seventeenth century BC. These remained the most important funerary texts for persons of high rank until the first century BC.

Although such spells could be inscribed on coffins, mummy wrappings, amulets or the walls of tombs, the usual practice was to write them on rolls of papyrus which would be placed either in the coffin or within the body of a wooden statuette of Osiris. The purpose of the spells was to ensure that the dead were fully equipped with the powers and sacred knowledge which they would need to obtain eternal life. Spells gave them control of every part of their being – not only the physical body but also the spirit aspects, particularly the *ba*, which was the Egyptians' nearest equivalent to the modern notion of the 'soul'. The *ba* had the freedom to leave the body in the tomb and to visit other parts of the cosmos – the world of the living, the sky and the Duat – before reuniting itself with the mummy each night. This concept of 'Coming Forth by Day' was so important that it became the title by which the Egyptians identified the whole corpus of spells which we now call the Book of the Dead.

Some spells conferred power over the natural forces of air, water and fire, while others invoked divine protection and enabled the dead to repel dangerous creatures and malevolent demons. The texts provided details of places which the dead would come to and divine beings whom they would meet. All these encounters were rites of passage – quite literally, for the dead had to display their

Opposite *The gods Ra (left) and Osiris (right). Papyrus of Nodjmet.*

knowledge of sacred matters to prove to the gods that they were worthy to pass on to paradise. The ultimate test of this kind occurred in the hall of judgement where the gods examined the deceased's conduct during his life. The Book of the Dead was in part a guide to the hereafter, containing the exact words which must be spoken at each encounter. It was not a statement of doctrine or belief. It does not narrate the myths of the gods but there are many allusions to them, often worded cryptically to distinguish the good from the evil. Nor was the Book of the Dead a finite, canonical work; it was a pool of texts which could be put to practical use, a repertoire which was gradually added to over the centuries and from which a selection could be made according to the requirements of the owner.

The individual spells of the Book of the Dead could be short or long, but they are distinguished from the earlier Pyramid and Coffin Texts by the regular inclusion of illustrations (vignettes). These represented the key elements of the words in pictorial form and contained as much magical power as the texts themselves. The modern numbering of the spells is based on the order in which they appear in manuscripts of relatively late date (about 650 BC onwards). Before this time there was little consistency in their arrangement, but the episodes which they describe reflect the underlying notion of a journey, beginning on the day of burial and leading the deceased via tests and challenges to paradise.

The manuscripts give a vivid insight into the Egyptians' hopes, fears and expectations. They are also major works of art and calligraphy. The finest papyri were custom-made, while many others were prefabricated, containing selections of popular spells with blank spaces into which the name of the eventual owner could be inserted. But even these copies would have been expensive; for the poor peasant who could not afford a Book of the Dead the passage to the afterlife would be a much more frightening experience and the outcome far less certain.

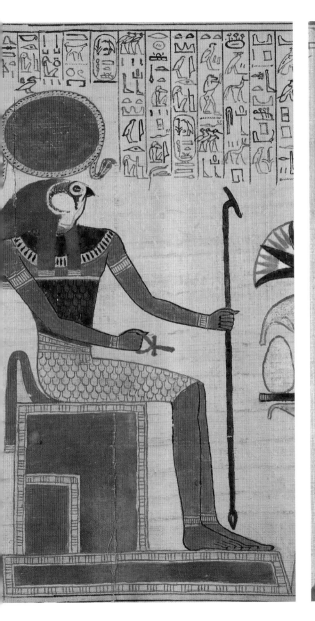
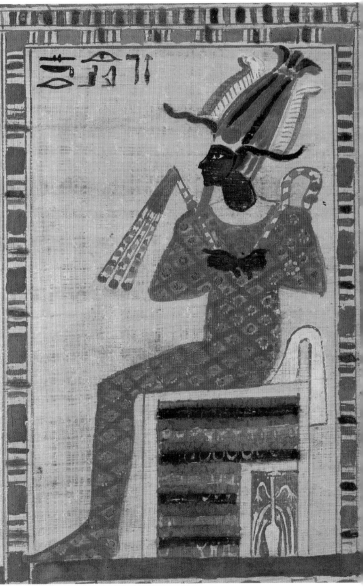

1

New Life for the Dead

THE ancient Egyptians regarded the person as a composite of physical and spiritual parts, which separated at death. In order to enter the afterlife these forms of existence had to be brought together again. It was thought that the rituals of death would make this possible.

First the corpse underwent special treatment – mummification. The parts most susceptible to decay were extracted. The body was cleansed of the fluids of decomposition, dried and anointed with oils and resins. It was wrapped in many layers of linen strips and sheets and adorned with a mask, transforming it into the shape of a divine being. This process traditionally took seventy days. Rituals were undoubtedly performed to accompany the mummification, but the words spoken did not form part of the Book of the Dead.

At the completion of this process came the day of burial, which formally marked the transition of the individual into the realm of the dead. The mummy was taken in procession to the tomb, accompanied by mourning relatives, friends and servants bringing grave goods. Spell 1 of the Book of the Dead contained the words to be spoken on this solemn occasion. At the culmination of the rituals, priests performed the Opening of the Mouth ceremony; the mummy's face was touched with implements which symbolically opened the eyes, mouth, nostrils and ears. This reanimated the dead person, restoring his bodily faculties and enabling the *ba*-spirit to enter and leave the mummy at will. This relationship between the *ba* and the mummy became the basis of the person's future existence.

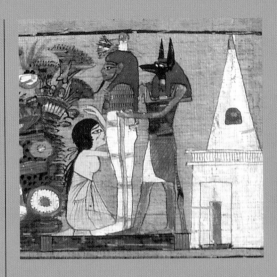

Ani's widow weeps before his mummy on the day of his burial. Papyrus of Ani.

The body was now put into the burial chamber in its coffin. The tomb was the earthly resting place of the mummy and it was also the point of contact between the natural and supernatural worlds. The living came there to sustain their dead relatives with prayers and offerings of food and drink, a service they hoped to receive from their own descendants in due course. The offerings nourished one of the spirit aspects of the dead called the *ka*. This entity remained in the tomb, but in the form of the *ba* – depicted as a human-headed bird – the dead person could 'come forth' every day and enter the mysterious realms of the sky and the Duat. He or she could now make the journey to paradise, using spells to obtain help on the way.

As the *ba* returned to the inert mummy each night, the journey to the afterlife was not a single finite event but a cycle in which life was repeated eternally. The goal of the dead person also varied from spell to spell because the Book of the Dead enshrined different traditions which were never fully synthesized.

Spell 1. The procession to the tomb on the day of burial. Ani's mummy, on a model boat, is dragged on a sledge with statues of the goddesses Isis and Nephthys at the head and foot to give protection. Ani's widow Tutu kneels at his side, weeping, while male mourners walk behind. Papyrus of Ani.

Overleaf *Spell 1. A group of female mourners wailing at Ani's funeral. Their hair is dishevelled, their breasts exposed and they beat their arms – all traditional signs of lamentation. Papyrus of Ani.*

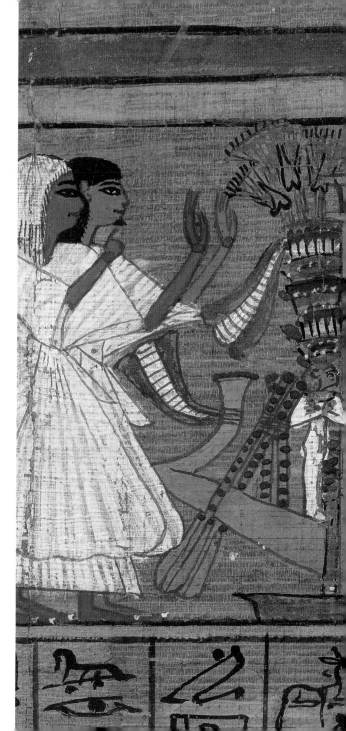

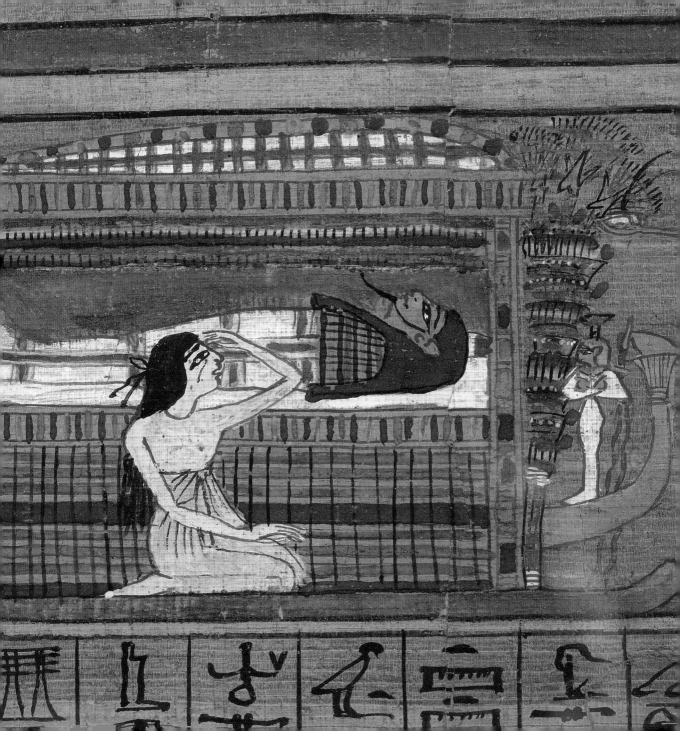

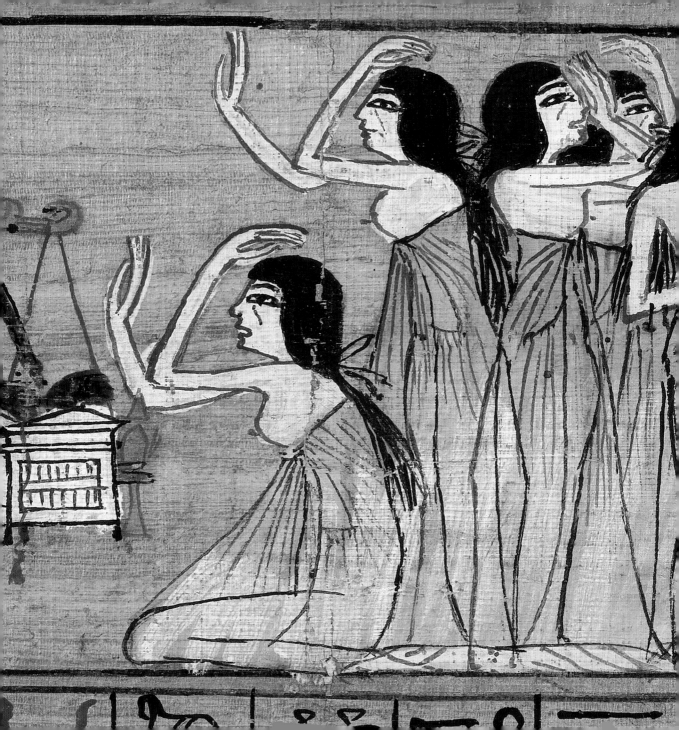

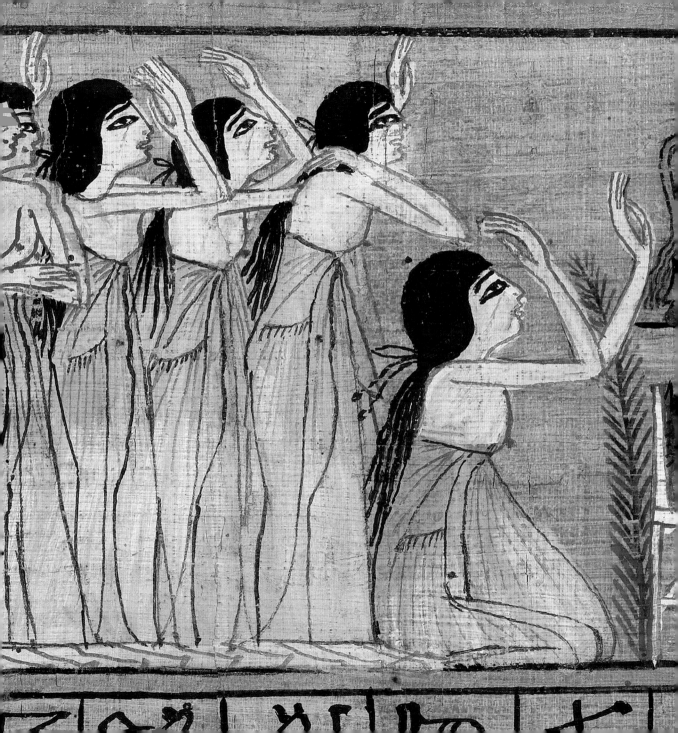

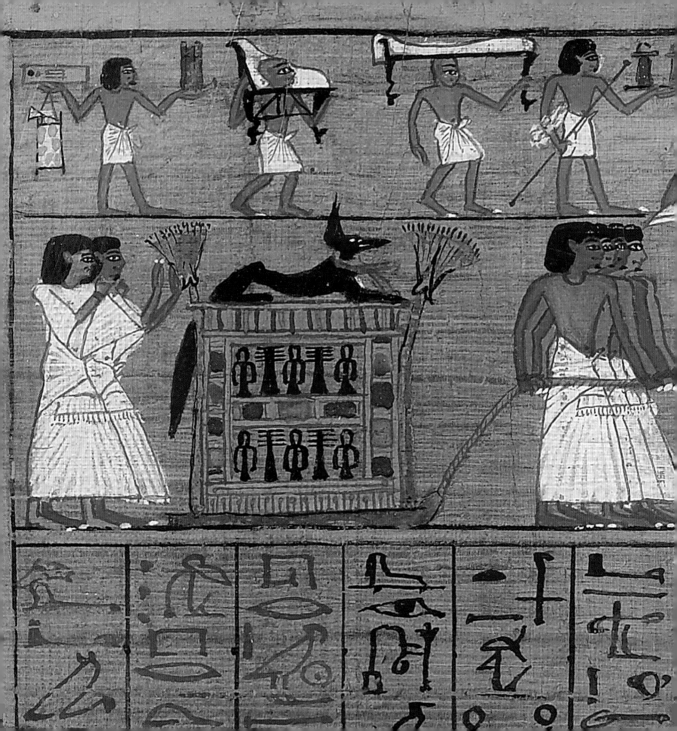

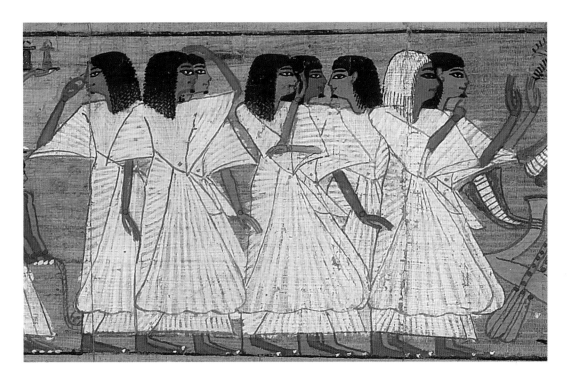

Spell 1. Making gestures of lamentation, a group of men follows the mummy of Ani to the tomb. Papyrus of Ani.

Spell 1. In Ani's funeral procession, servants carry furniture for the tomb and men drag a sledge on which is the canopic chest containing the embalmed internal organs of the dead man. Papyrus of Ani.

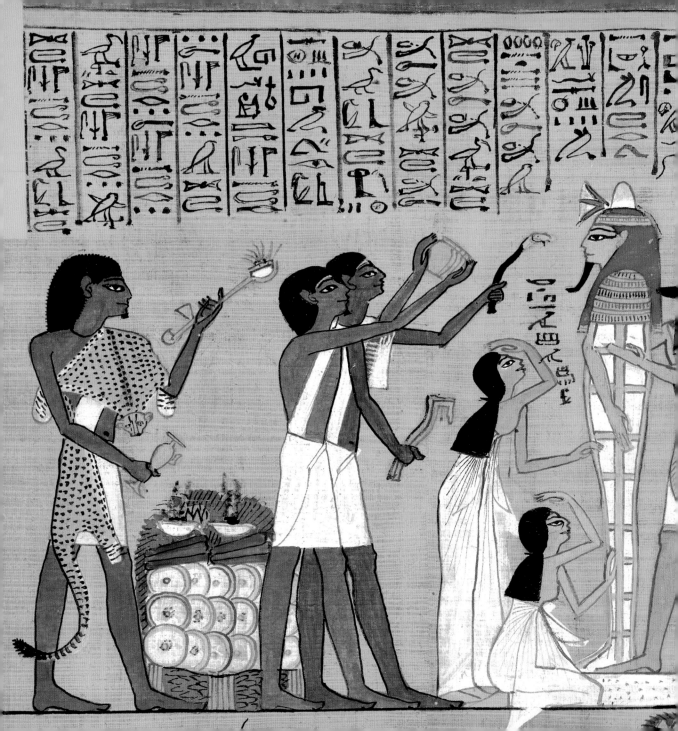

'My mouth has been given to me that I may speak with it in the presence of the Great God, lord of the West. My hand shall not be thrust aside in the tribunal of the gods, for I am Osiris, lord of Rosetjau.'

(Spell 22, 'for giving a mouth to the deceased')

The ritual of the Opening of the Mouth performed on the mummy of Hunefer at the entrance to his tomb (right). While his widow and daughter lament, priests touch the face of the mummy with ritual implements. The jackal-headed god Anubis, or perhaps a priest impersonating him, holds the mummy upright. Papyrus of Hunefer.

'May you cause my *ba* to come to me from wherever it may be … O heavenly ones, do not appropriate my *ba*. If your allowing my *ba* to see my corpse is delayed, you shall find the Eye of Horus standing up against you…'

(Spell 89, 'for letting a *ba* rejoin its corpse')

Spell 1. At left, the Opening of the Mouth is performed on the mummy of Nebqed. Beneath the entrance to the tomb his ba-spirit is shown travelling down a vertical shaft to the burial chamber in which his mummy lies. Nebqed is also shown freed from his wrappings and rising from the tomb under the life-giving rays of the sun. Papyrus of Nebqed, Musée du Louvre, Paris.

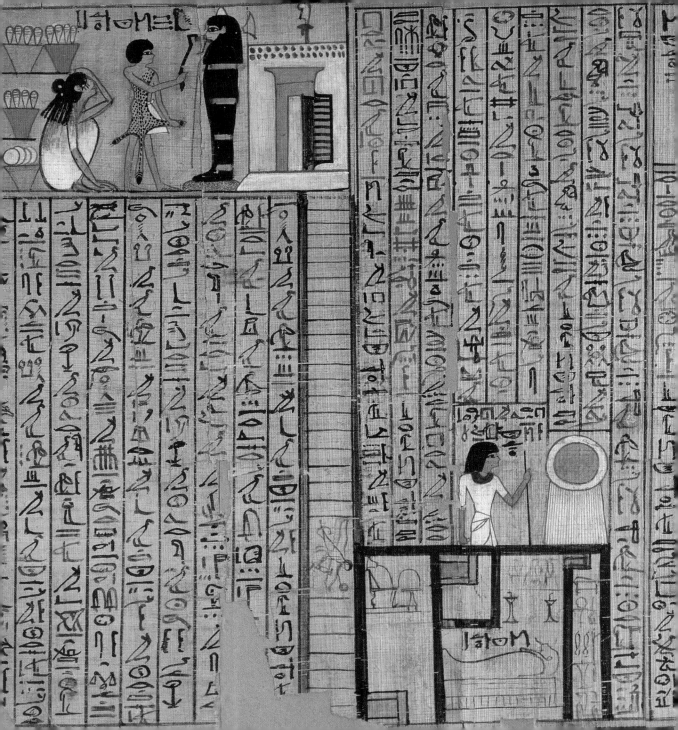

Spell 89. Ani's ba, *depicted as a human-headed bird, hovers over his mummified body lying on a lion-bed with incense burners at each end. Papyrus of Ani.*

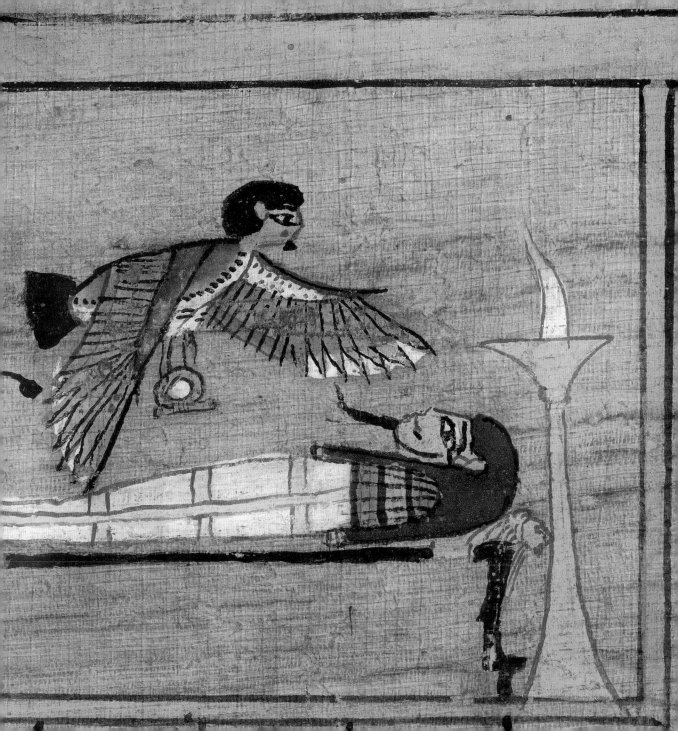

2

Protecting the Mummy

THE preservation of the corpse was essential to survival after death. The *ba*-spirit had to be reunited with the body at the end of each day, and so much effort was devoted to keeping the mummy safe inside the tomb. The burial chamber where it lay was usually below the ground and was sealed after the funeral. But however well the mummy was protected physically, it remained vulnerable to attack by the forces of the god Seth. According to mythology he had murdered his brother Osiris and dismembered his body. The dead person, like Osiris, was also at risk.

The mummy in its sepulchre was equated with the body of Osiris, its mythical prototype. It was therefore surrounded by the magical protection of deities who watched over Osiris and ensured his resurrection – the embalmer-god Anubis, the sister-goddesses Isis and Nephthys, and the four Sons of Horus, who were responsible for the physical well-being of the corpse and particularly the internal organs. Spell 151 of the Book of the Dead contained the words of these deities, and its vignette depicted them in their appointed stations around the mummy. In addition, the spell included the words to activate four special amulets which were to be mounted on mud bricks and placed in niches in the walls of the burial chamber. These objects mimicked the rituals which were carried out at childbirth to ward off harmful forces from the four points of the compass. This echo of birth rituals emphasized the idea that the dead person would be reborn.

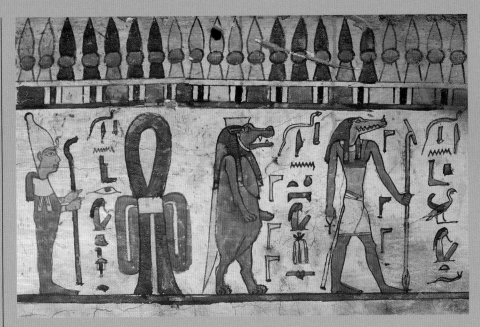

Protective gods and emblems on the coffin of Pasenhor.

Another layer of protection was provided by objects placed on the mummy itself. The head was covered by a mask which represented the deceased as a transfigured spirit, with the shining golden skin of a divine being. Part of spell 151 explains the function of the mask, which is called the 'head of mystery'. It enables the dead person to see, and it protects him from enemies because he has become wholly divine. Every part of his head – eyes, ears, nose, hair – is equated with the corresponding part of a god. The mummy was also adorned with amuletic collars (often incorporated into the mask) which gave further protection, and other amulets in different forms. The Book of the Dead contains the words of the spells which activated several of these.

Spell 151. Protective forces positioned around the mummy in its burial chamber. Anubis and the ba-spirit stand beside it, Isis and Nephthys kneel at the foot and head, and the Sons of Horus are nearby. Four amulets ward off dangerous forces from the points of the compass. Hieroglyphic texts record the words of each deity, expressing their protective roles. Papyrus of Muthetepty.

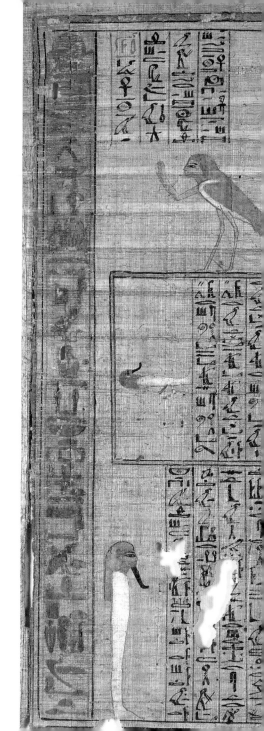

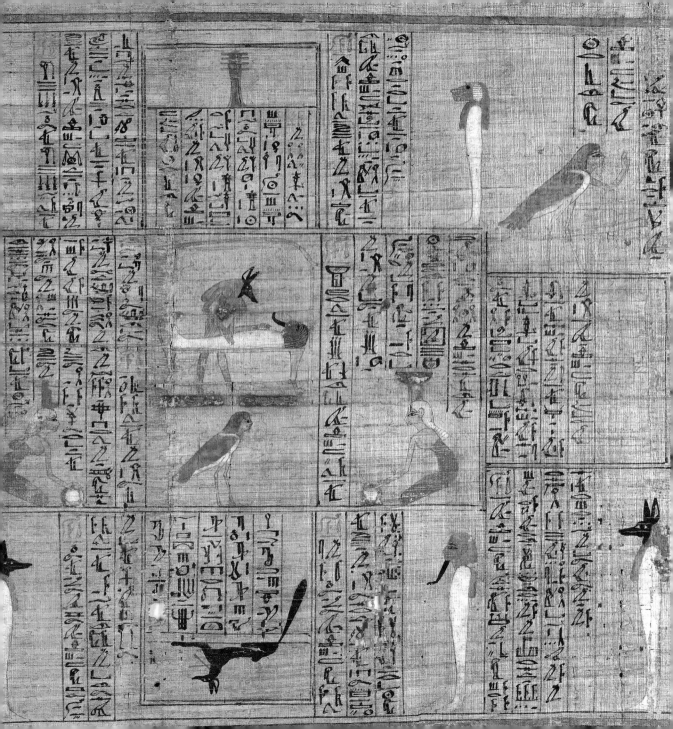

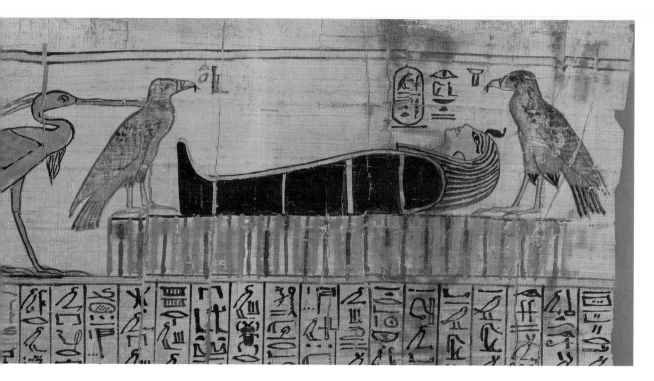

In spell 17 the mummy is again shown lying under the protection of Isis and Nephthys, here in the form of kites. Queen Nodjmet's mummy rests on a support with panelled doorway decoration. Papyrus of Nodjmet.

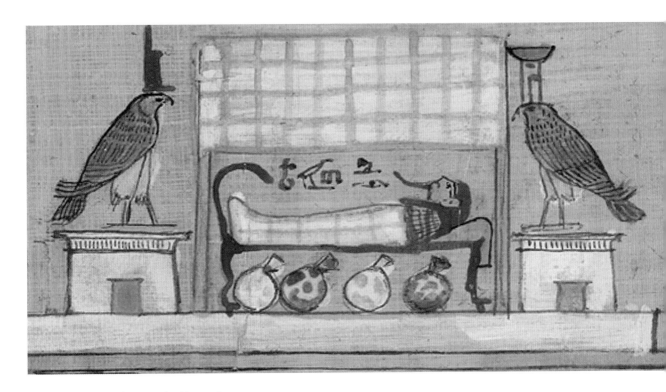

Hunefer's mummy lies on a bed beneath a canopy. Under the bed are four bags tied at the neck, perhaps containing natron for the preservation of the corpse. Papyrus of Hunefer.

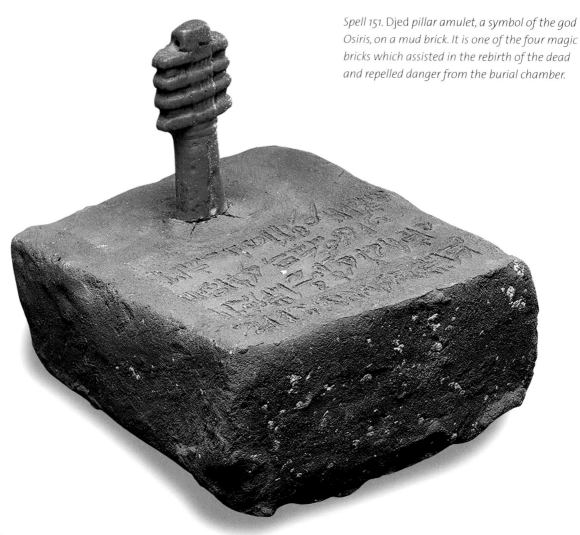

Spell 151. Djed *pillar amulet, a symbol of the god Osiris, on a mud brick. It is one of the four magic bricks which assisted in the rebirth of the dead and repelled danger from the burial chamber.*

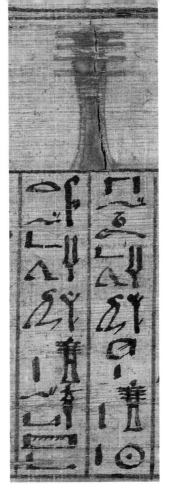

'O you who come seeking to repel my steps, you whose face is hidden; your hiding place is illuminated. I am he who stands behind the *djed* pillar, I am indeed he who stands behind the *djed* pillar on the day of preventing slaughter. I am the protection of the deceased.'

(Spell 151, text for the *djed* pillar)

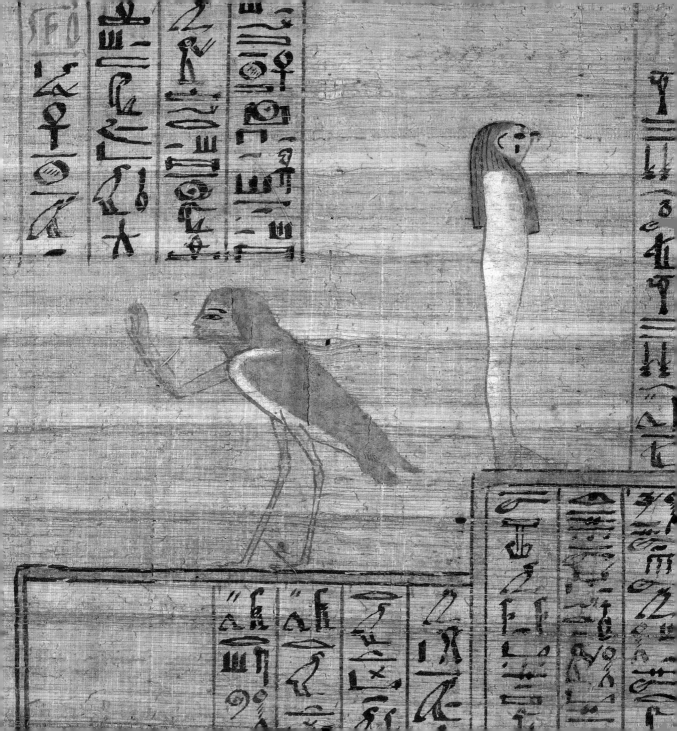

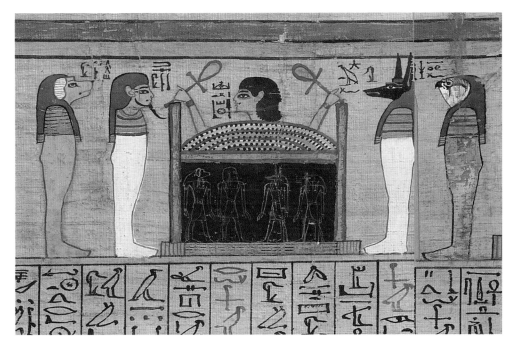

Spell 17. A stylized depiction of a coffin with a
vaulted lid, from which the head of the deceased
emerges. At each side, two of the four Sons of
Horus stand as protectors of the occupant. Papyrus
of Ani.

Spell 151. A ba-bird praises the sun-god, and
the falcon-headed Qebehsenuef, one of the
Sons of Horus, protects the deceased. Papyrus
of Muthetepty.

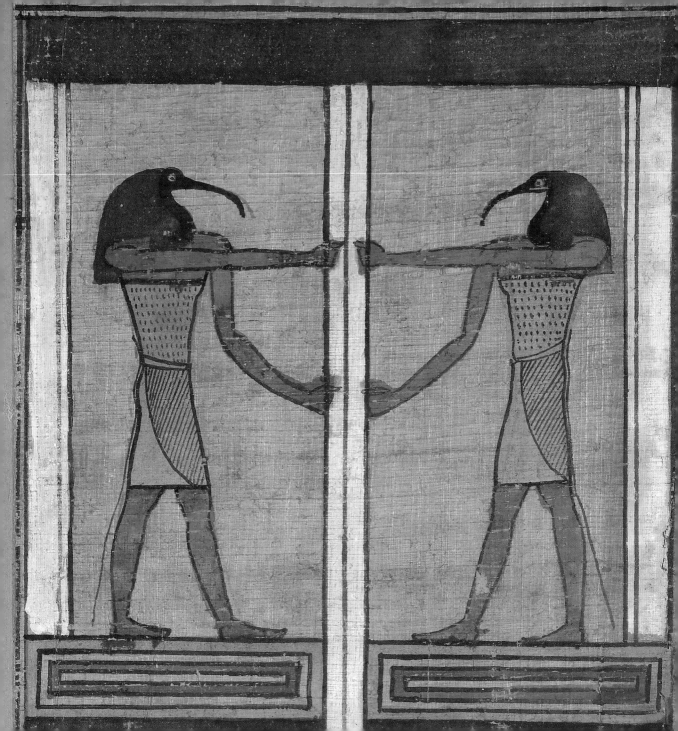

Opposite *Spell 161. Two of four figures of the god Thoth, who is said to make openings in the sky to release the north, south, east and west winds. These were intended to blow the breath of life to the nose of the deceased. Papyrus of Hor.*

Below *On the coffin of Henutmehyt are painted figures of gods and short passages from spells 151 and 161 of the Book of the Dead. In this way the images and texts from the papyri are arranged in an almost three-dimensional evocation of the divine forces which protected the dead in the tomb.*

'As for any noble dead for whom this ritual is performed over his coffin, there shall be opened for him four openings in the sky … As for each one of these winds which is in its opening, its task is to enter into his nose.'

(Note to spell 161, 'for breaking an opening into the sky')

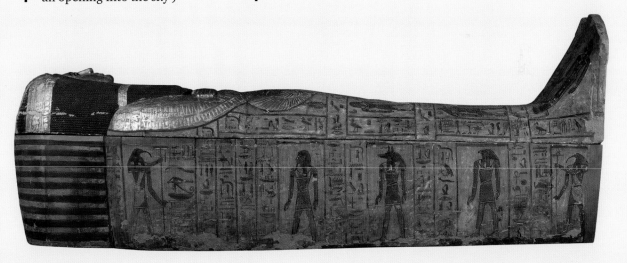

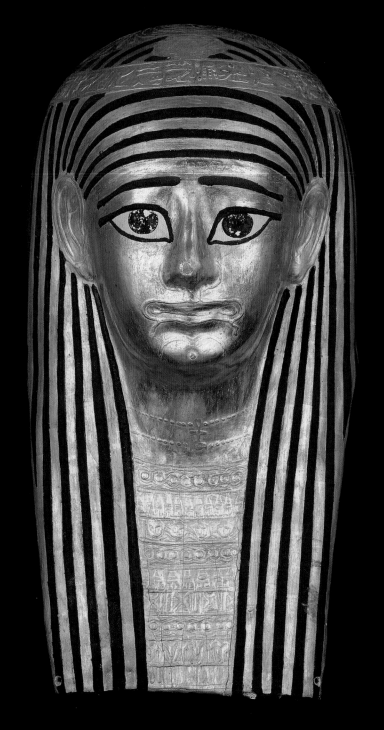

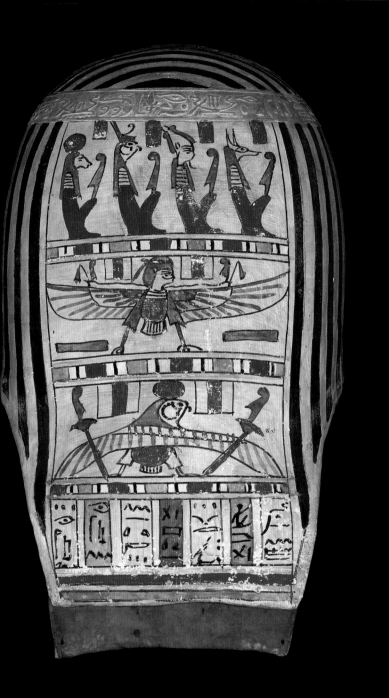

Spell 151. Around the brows of this gilded mummy-mask is inscribed a passage from spell 151 in which the divine nature of the dead person's members is expressed. The gilded face is a further symbol of divinity and the figures of deities on the back provided protection.

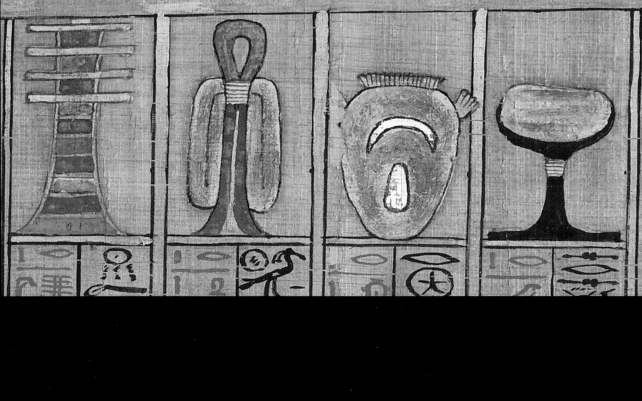

'You have your blood, O Isis; you have your power, O Isis; you have your magic, O Isis. The amulet is a protection for this Great One, which will drive away whoever would commit a crime against him.'

(Spell 156, 'for a knot-amulet of red jasper')

 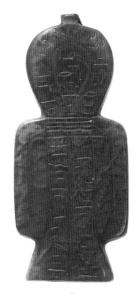 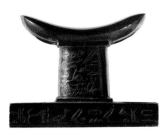

Opposite *Spells 155, 156, 29B and 166. Four important amulets to be placed on the mummy are illustrated and accompanied by the words which were believed to activate them. From left to right, the* djed *pillar, the* tit *(Isis knot), the heart amulet and the headrest. Papyrus of Ani.*

Above *Examples of the four amulets illustrated in Ani's Book of the Dead papyrus.*

3 *Encountering the Divine*

WHILE the mummy remained in the tomb, the deceased in spirit form entered the realm of the dead – a world of the imagination which was usually envisaged as being beneath the earth. The Duat contained many features which were familiar from the everyday world – rivers, dry land, islands, lakes, fields, caverns – but there was also a fantastic element: lakes of fire, walls of iron, corn which grew to abnormal height. It was inhabited by divine beings – not only the well-known gods but many strange supernatural creatures.

The full extent and the geography of the Duat are not explained in the Book of the Dead, but some spells describe specific features which the dead person could expect to find there, such as gates, mounds and caverns. The descriptions of these localities are not realistic, but are concerned with the divine forces which were believed to dwell there, whose consent the deceased had to gain in order to pass on his way without hindrance.

Several spells enumerate a series of gates, symbols of transition, through which the deceased had to pass. They belong to a conception of the Duat as a series of concentric enclosures, at the core of which was the most sacred spot where Osiris dwelt. As in an Egyptian temple, only those who had been initiated into the most sacred knowledge were permitted to penetrate to the holy of holies. The spells of this type in the Book of the Dead list varying numbers of gates, but the procedure to be followed is generally the same. As the deceased approaches each gate he speaks to the guardians: 'I know you and I know your names', a magical device

for exercising power over someone. Using the information in the spell he must demonstrate his knowledge by speaking the often complex names and epithets of the guardians. They are depicted as monstrous creatures armed with knives, and will either drive away or kill anyone who does not know the correct procedure.

Similar principles applied to features called 'mounds' – sacred places depicted in diagrammatic form, which also had divine guardians or occupants of a threatening character. Again the deceased had to satisfy them that he was worthy by speaking the appropriate formulae. His knowledge was also to encompass other divine beings who dwelt in the beyond – the many gods of the caverns, the 'souls' of sacred places and the bull of heaven, who, with his seven cows, had to be named accurately before the deceased could receive food from them.

This realm is not mapped or described in consistent terms in the Book of the Dead, and the relationship between gates, mounds and caverns in space and time is never made explicit. There are many possible paths through the Netherworld, and many modes of travel – by boat, on foot or in the form of different creatures both real and mythical. Yet the notion of a linear path linking this world and the next can occasionally be recognized (see p. 57).

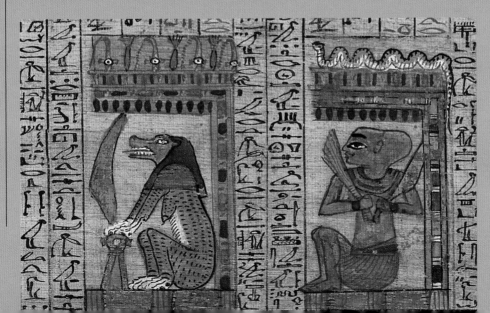

Two guardians of the gates of the Netherworld. Papyrus of Ani.

43

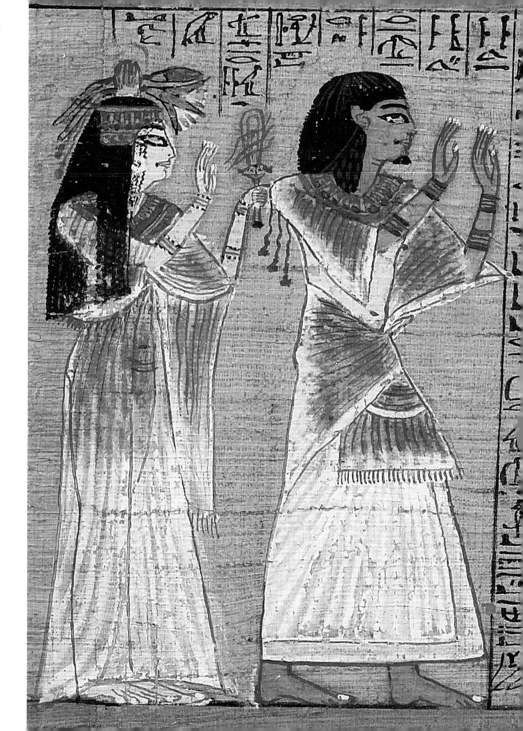

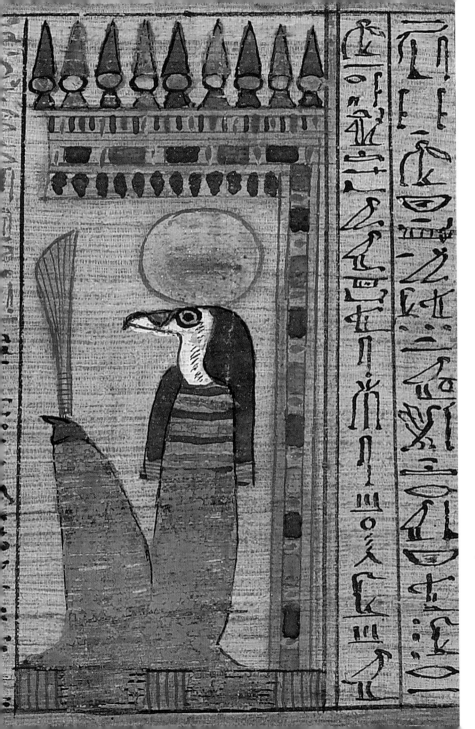

Spell 146. Ani and his wife Tutu stand before the first of the 21 gates of the House of Osiris, guarded by a vulture-headed deity named 'the Terrible One'. Papyrus of Ani.

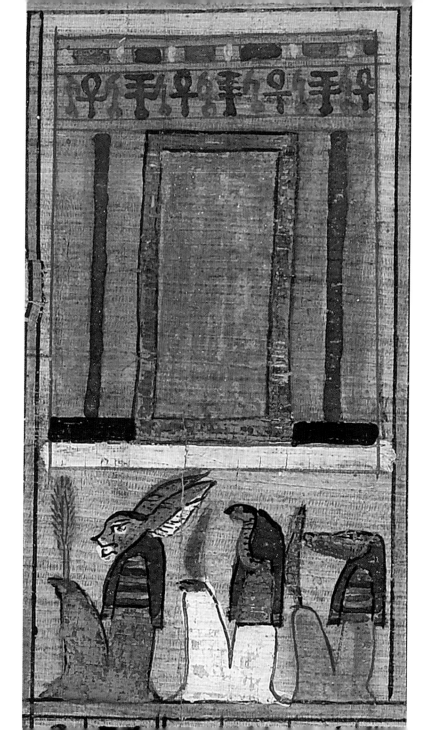

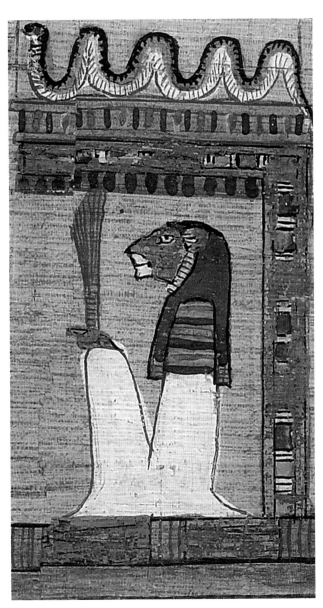

Spell 146. The second of the 21 gates with its lion-headed guardian. The name of the gate is 'Lady of Heaven, Mistress of the Two Lands, the Wailer, Lady of All, who numbers all men.' Papyrus of Ani.

Opposite *Spell 144. The first of the seven gates of the House of Osiris, with its divine keeper, guardian and announcer. Their names are 'He whose face is downward, numerous of shapes', 'Eavesdropper' and 'Sad of Voice' and they are depicted with the heads of a hare, a snake and a crocodile. Papyrus of Ani.*

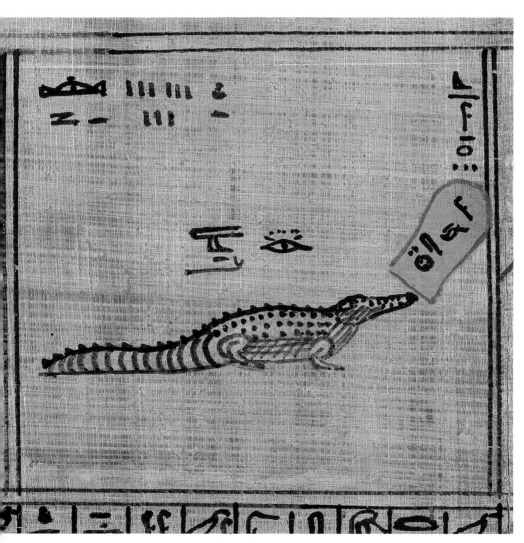

Left *Spell 149. 'He who watches what he would seize', the crocodile denizen of the ninth mound of the Netherworld. The object above the crocodile's snout represents a place in the hereafter named Ikesy. Papyrus of Nu.*

Right *Spell 149. The eleventh mound, with its inhabitant, a jackal-headed god who wields a knife. The stepped enclosure may represent a ladder to the sky, set up by the dead person, as described in the spell. Papyrus of Nu.*

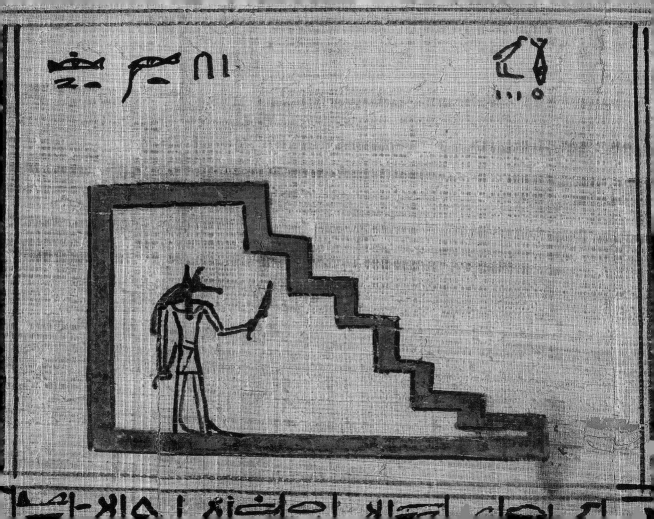

'The Field of Reeds. The god who is in it is Ra.

The very high mountain.

The Mound of transfigured spirits.

The Mound of Wenet. The god who is in it is Destroyer of Souls.

The river of flaming fire.

The Mound of Kheraha. The god who is in it is Hapi.'

(Spell 150, names of mounds of the Netherworld)

Spell 150. An alternative listing of the mounds of the Netherworld. Here, fifteen mounds are illustrated instead of the fourteen of spell 149. The four snakes (upper right) may represent the points of the compass. Papyrus of Userhat.

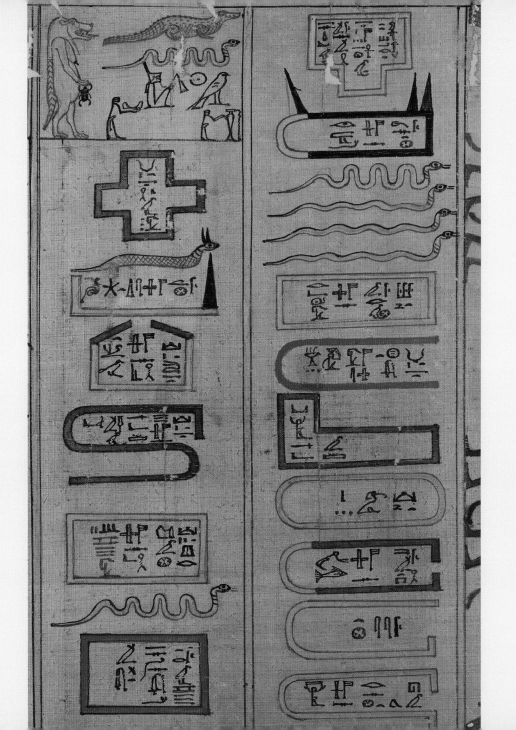

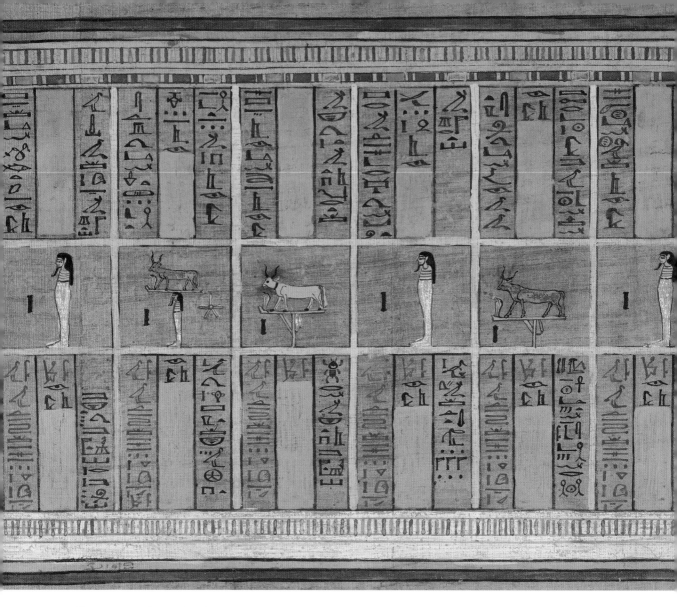

Spell 168. Deities who dwell in the ninth cavern of the Netherworld. The texts explain their duties, which include warding off evil from the deceased and allowing him 'to be with them for ever in the realm of the dead.' Papyrus of Bakenmut.

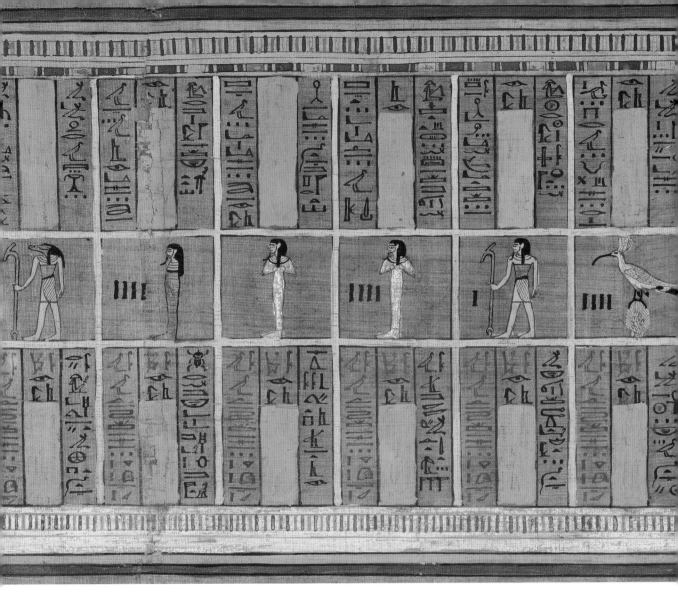

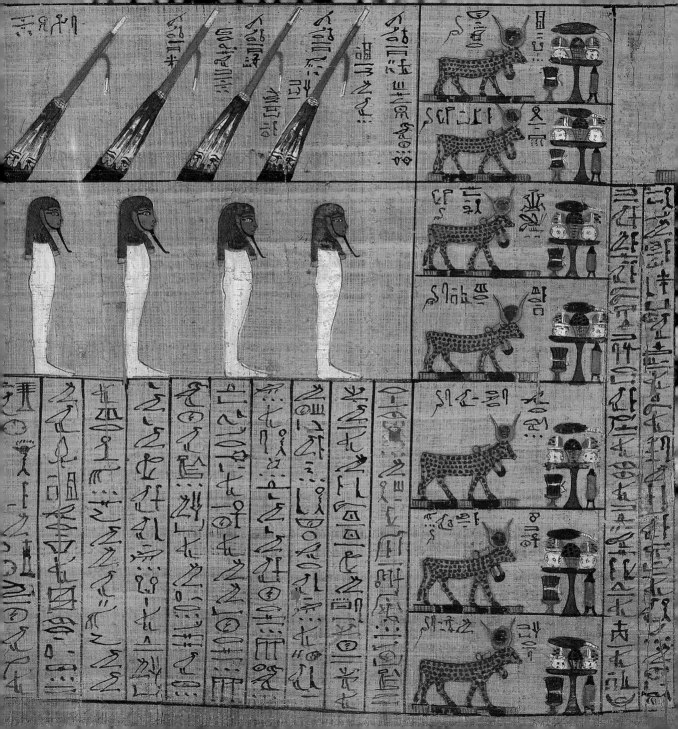

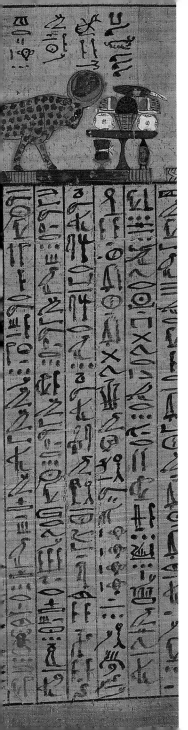

The names of the cattle are:
Mansion of Kas, Mistress of All.
Silent One who dwells in her place.
She of Chemmis whom the god ennobled.
The Much Beloved, red of hair.
She who protects in life, the particoloured.
She whose name has power in her craft.
Storm in the sky which wafts the god aloft.
The Bull, husband of the cows.

(Spell 148)

Spell 148. The illustration shows inhabitants and features of the hereafter: the bull and his seven cows, whose names the deceased must know in order to receive sustenance; and the four rudders of the sky with their deities. Papyrus of Nakht.

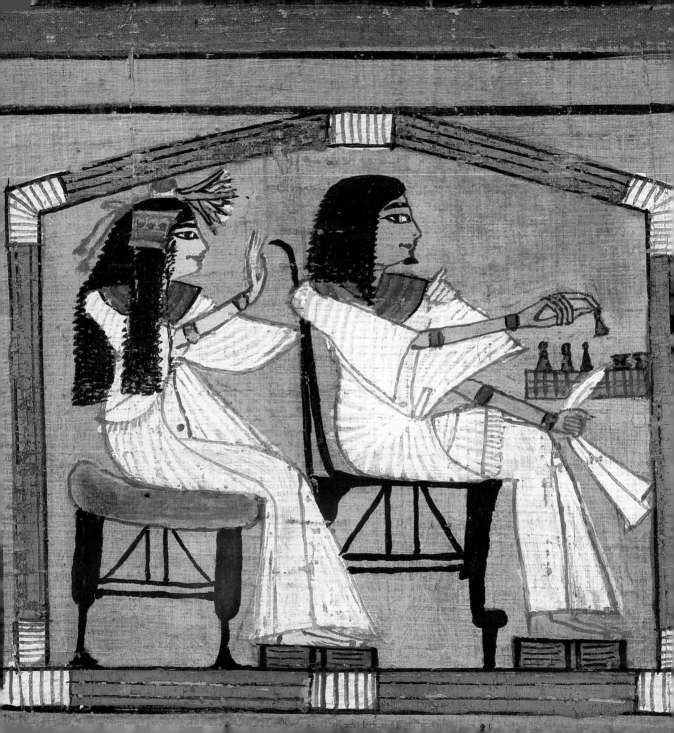

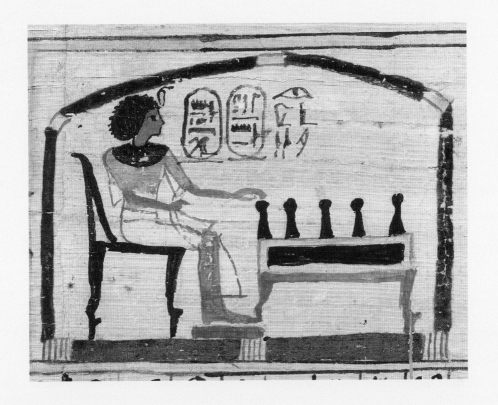

Spell 17. The popular board-game senet *('Passing'), with its path of thirty squares, was interpreted symbolically as a metaphor for the journey from death to afterlife. The deceased is often depicted playing the game in spell 17 of the Book of the Dead. Papyrus of Ani (left) and papyrus of Nodjmet (above).*

4 *Special Powers*

IN order to exist in the hereafter it was essential for the person to have full control over all aspects of his being. Numerous spells in the Book of the Dead made this possible.

Spell 42 ensured that every part of the body was divine, like the physical members of gods, but there was also special concern to retain possession and control of particular body parts, the loss of which would be disastrous. Spell 43 prevented the head from being cut off, while a distinct group of spells was devoted to safeguarding the heart. This was the most important organ of all, the only one which remained in the body after mummification. It was regarded as the centre of the person's intelligence – his mind and memory – and it would play a key role at the judgement.

Other spells sustained the spirit aspects of the individual, of which the *ba* played the most important role in the afterlife. There were spells to enable the *ba* to reunite itself with the mummy when required and to allow it the freedom to 'come forth' and to travel to the world of the living and the realm of the gods. Even in spirit form, the deceased would be dependent on the natural elements, and so other spells gave control over air, water and fire, enabling the dead person to breathe, to drink, and to avoid harm by being burnt or scalded with hot water.

A self-contained group of spells enabled the deceased to transform himself into different beings, particularly animals which possessed the ability to move freely through air, water or sand. Among these are spells to transform into a

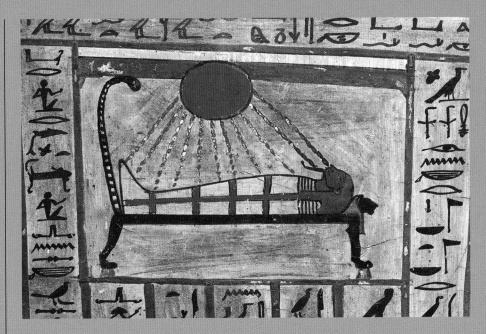

falcon, a heron, a swallow, a snake and a crocodile. Others enabled one to turn into the god Ptah or a lotus flower, regarded as a potent symbol of the renewal of life since the lotus opens when the sun shines on it. A spell also existed to change the deceased into a *ba*, indicating that the transformation spells were closely linked with the concept of 'coming forth by day'.

Knowledge was of paramount importance. Besides knowing how to make spells work, one needed to display knowledge to the gods in order to prove one's worth. Another text which was loaded with sacred knowledge was spell 17. This very long text is chiefly concerned with the nature of the creator-god. The spell is partly in the form of a dialogue with editorial glosses and comments on some of the more obscure statements to explain their symbolic meaning. This approach ensured that the deceased was equipped to answer even the most challenging questions.

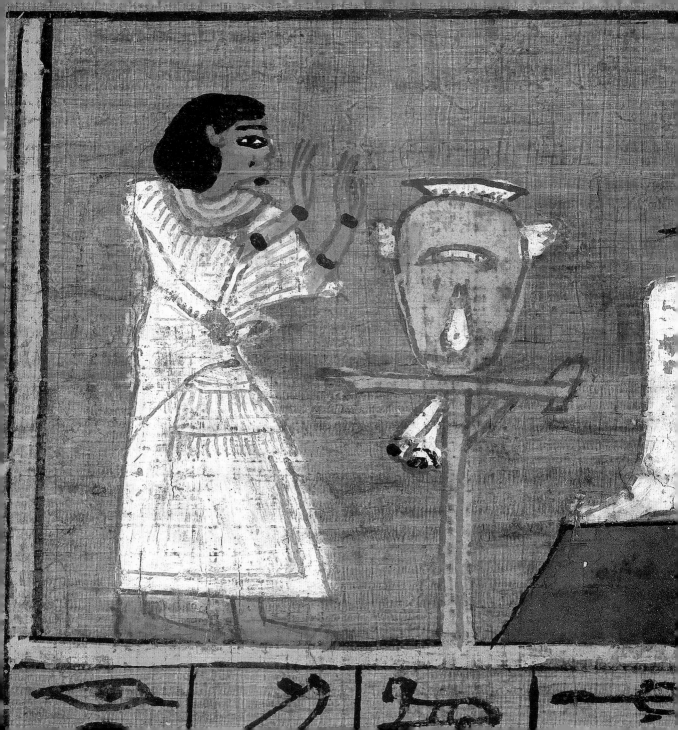

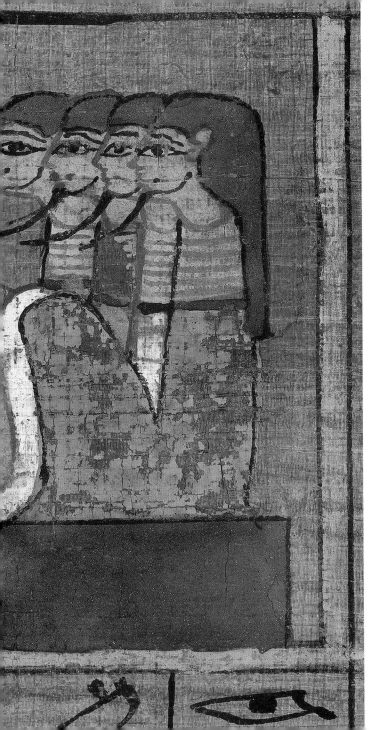

*Spell 27. While his heart rests upon a stand, Ani
worships four gods, 'those who seize hearts',
to prevent them from taking away his heart or
from causing it to betray him at the judgement.
Papyrus of Ani.*

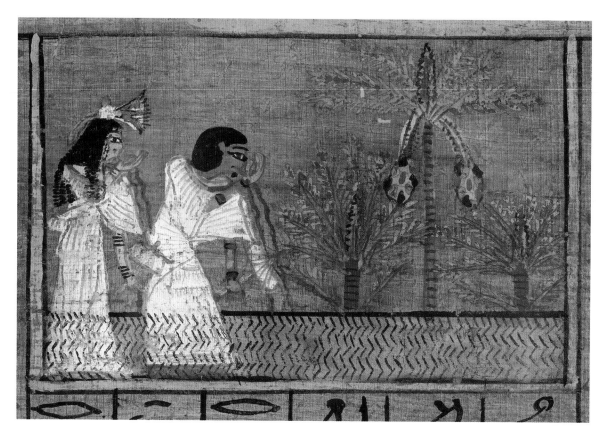

Spell 58. This spell gave the dead the ability to breathe air and have power over water. Ani and Tutu stand in a pool, holding miniature sails (symbolizing air) and drinking water. Papyrus of Ani.

Spell 59. Ani, kneeling beside a pool, receives food and drink from the maternal goddess Nut, who stands in the branches of a tree. Papyrus of Ani.

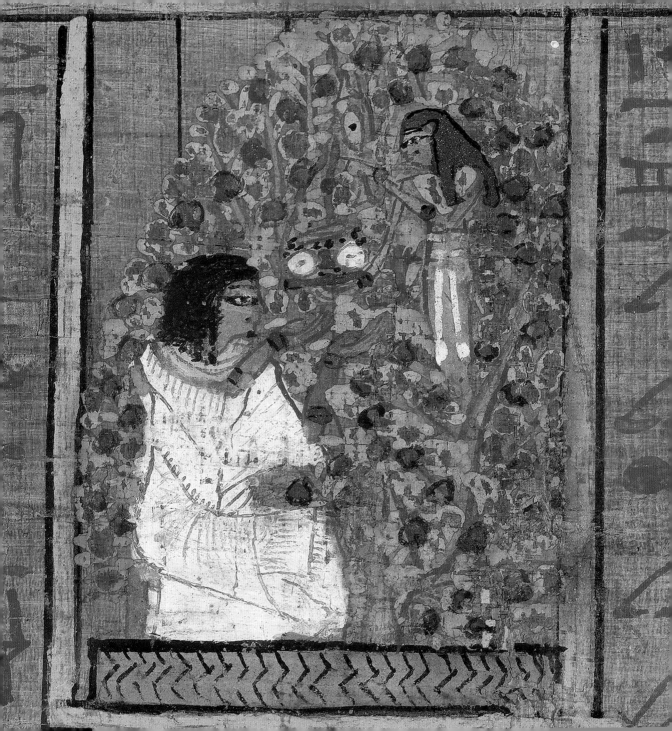

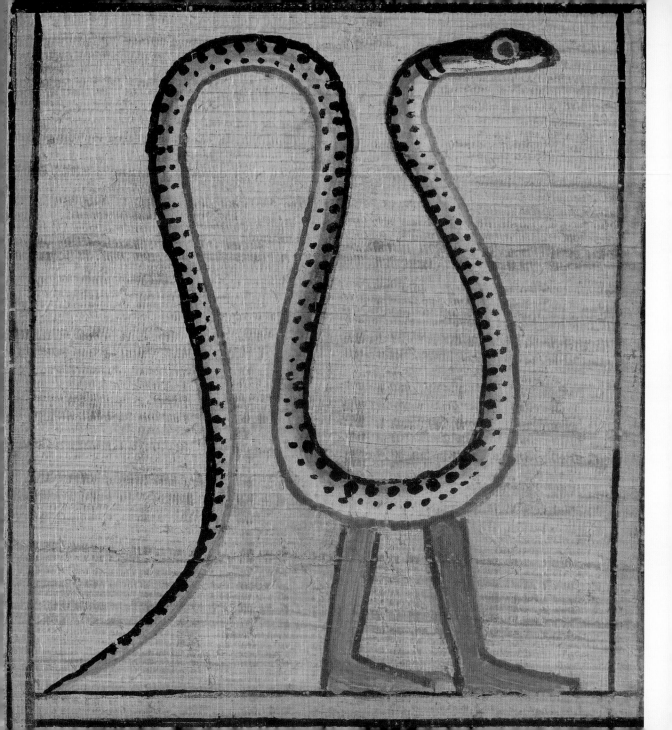

'I am the Sata-snake, long of years, who sleeps and is reborn each day. I am the Sata-snake, dwelling in the limits of the earth. I sleep and I am reborn, renewed and rejuvenated each day.'

(Spell 87, 'to transform into the Sata-snake')

Spell 87. The words of this spell emphasize the idea of the cyclical character of life, which could be endlessly renewed. In the illustration the snake is equipped with human legs to indicate the power of swift movement which it also possessed. Papyrus of Ani.

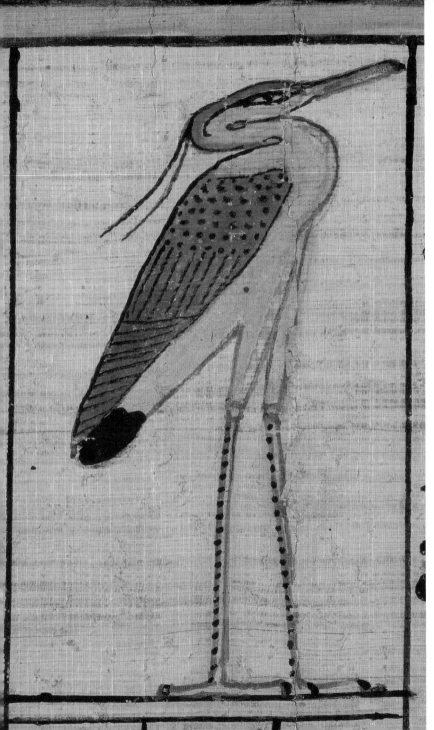

Spell 83. The spell enabled the deceased to transform into a benu. *This was a mythical bird, resembling a heron with a long crest, which was the manifestation of the soul of the sun-god Ra. Papyrus of Ani.*

Spell 86. This text transformed the deceased into a swallow. This bird, a symbol of regeneration, was closely associated with the sun-god and was often depicted perching on his boat. An ancient commentary states that those who knew this spell would not be turned away from the gates of the Netherworld. Papyrus of Ani.

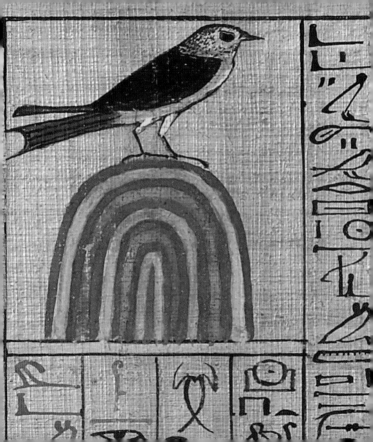

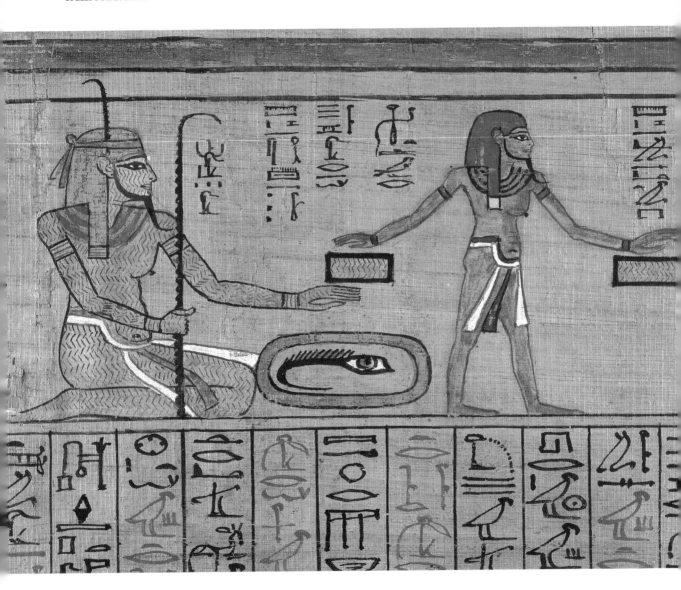

Right *Spell 17. The* wedjat, *or Eye of Horus, was a powerful symbol of protection, both for the living and the dead. According to the mythology of the god Horus his eye was injured and later healed; as an amuletic device it came to signify the state of being whole or unharmed. Papyrus of Ani.*

Opposite *Spell 17. This long and complex spell contains a discussion of the nature of the creator-god, with explanations of many obscure religious terms which the deceased would need to know. Among the different gods who are mentioned are the personifications of 'Eternity' and 'Sea'. Papyrus of Ani.*

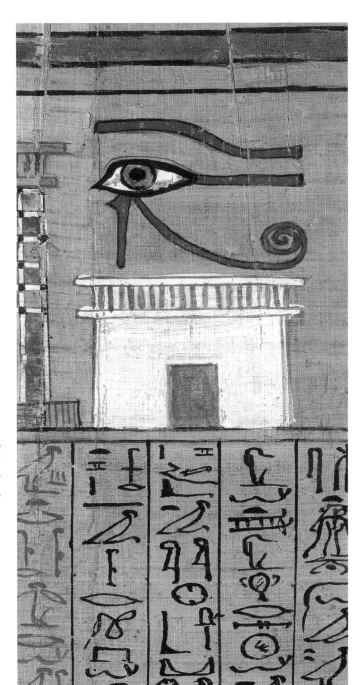

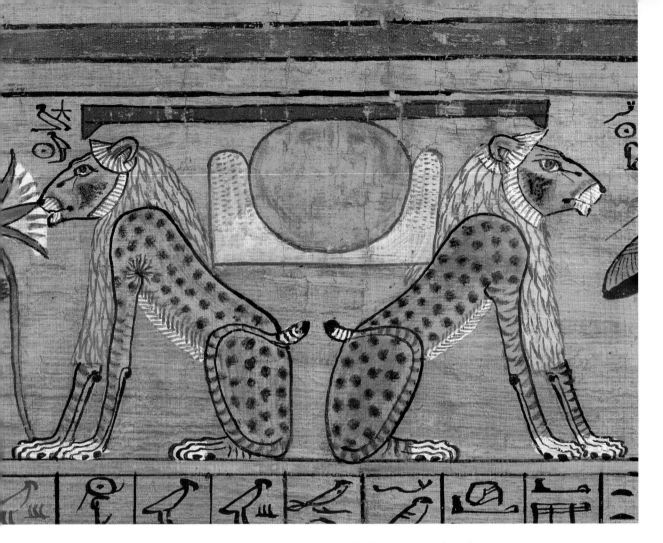

Spell 17 contains the words 'To me belongs yesterday, I know tomorrow'. The two phrases referred obliquely to the gods Osiris and Ra, whose connection with each other symbolized the endless cycle of life. This passage is illustrated in the papyri of Ani (left) and Nodjmet (right) with the image of two lions, back-to-back. One represents yesterday, the other tomorrow, and between them the sun rises from the eastern horizon into the blue vault of the sky.

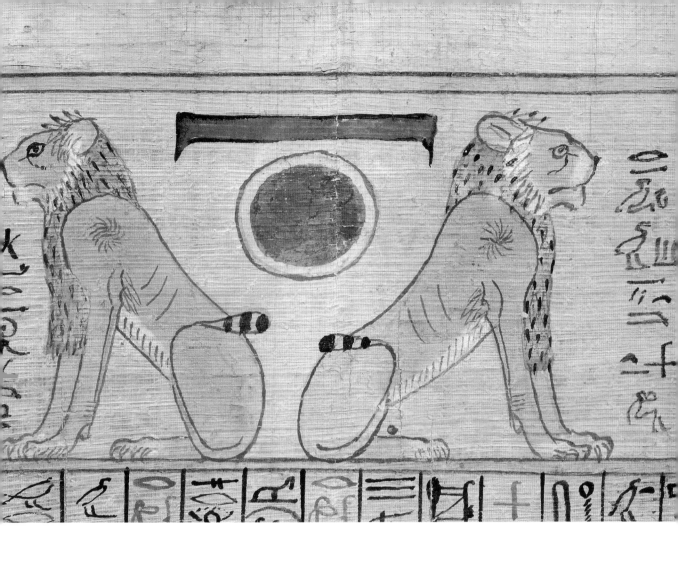

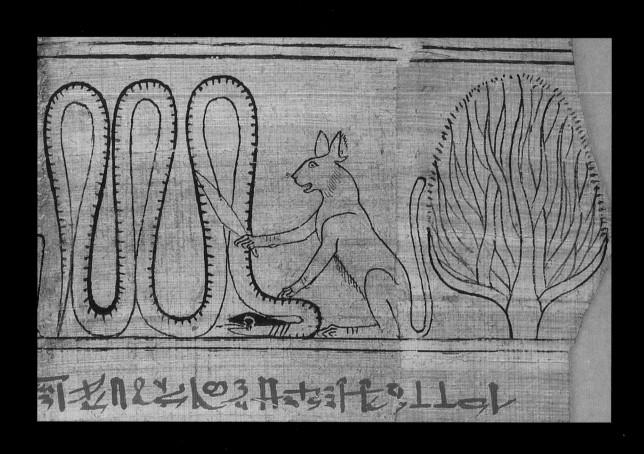

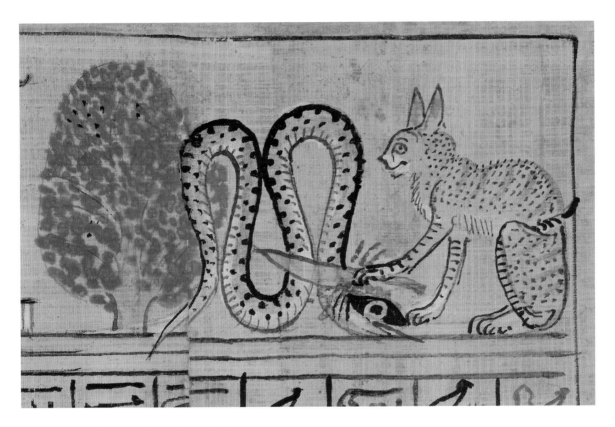

*Spell 17. Among the varied illustrations of spell 17
is a vivid picture of the sun-god in the form of a
cat slaughtering his enemy, the snake of darkness
who tried each night to prevent the god from
rising into the sky at dawn. Papyrus of
Nesitanebisheru (opposite) and papyrus of
Hunefer (above).*

5 Escaping Dangers

THE Netherworld was a place of many dangers, and to avert these magic was a most important tool. Numerous spells in the Book of the Dead equipped the deceased to play an active role in driving away harmful creatures such as snakes and crocodiles, which might attack him as he followed the paths to eternal life. Crocodiles posed the additional threat of stealing the deceased's magical power and so had to be repelled. There was also a spell against an insect, which was perhaps feared because some types of beetle devoured the corpses of the dead, a possibility which would deprive the *ba* of its physical counterpart.

Snakes were regarded as creatures of great power, highly dangerous unless they could be controlled. In the Egyptians' view the Netherworld was populated by many different snakes, and several spells empowered the deceased to drive them off. The most fearsome snake of all was Apep, the great enemy of the sun-god. Each night the god's entourage had to defeat him in the Netherworld so that the sun could reach the horizon in order to renew life throughout the world at dawn. In some spells the deceased acts as the god's champion in this fight; by participating in Ra's eventual triumph he ensured his own rebirth.

For the unwary or ill-prepared there were numerous other dangers to be confronted. They might be trapped in the giant nets which the gods stretched between heaven and earth to catch those who were unworthy of entering the afterlife. To become the captive of the gods could lead to destruction. The Netherworld was not simply a paradise; it was also a place of punishment and

torment for the enemies of the gods – fates the deceased anxiously wished to avoid. Thus some spells allowed him to pass safely by those places where the wicked were slaughtered by executioners 'sharp of fingers'. Another alarming possibility was that of being turned permanently upside down, an ancient metaphor for the defeat of an enemy. This resulted in the digestive process being reversed so that one was forced to eat faeces and drink urine. Spells also prevented the deceased from having to endure this. The worst possible disaster was that one might die again in the Netherworld. This second death meant the final end of one's existence, but even this could be averted by spells.

In other spells the dead person assumes a more passive role, lying inert in his tomb while magical words and images invoke protective forces to shield him from harm. The rare spell 182 is illustrated by rows of deities who guarded the deceased, armed with knives, snakes and lizards, attributes which testified to their control over hostile powers. These gods did not differ greatly from those who guarded the gates and mounds in the Duat, but once the deceased had gained their approval by his correct speech they became his protectors.

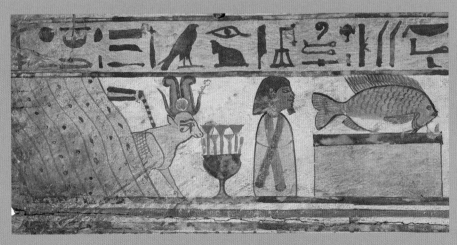

The Hathor cow and other protectors on the coffin of Horaawesheb.

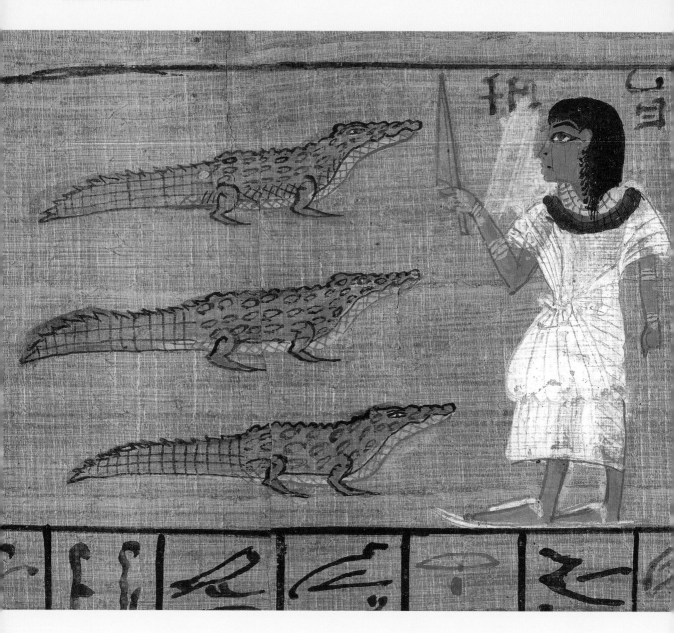

> 'Get back! Retreat! Get back, you crocodile!
> Do not come against me, for I live by my
> magic. May I not have to tell this name of
> yours to the Great God who sent you.'
>
> (Spell 31, 'for driving off a crocodile')

Spell 31. The army commander Nakht holds up a knife to repel three crocodiles who come to steal his magic power. Papyrus of Nakht.

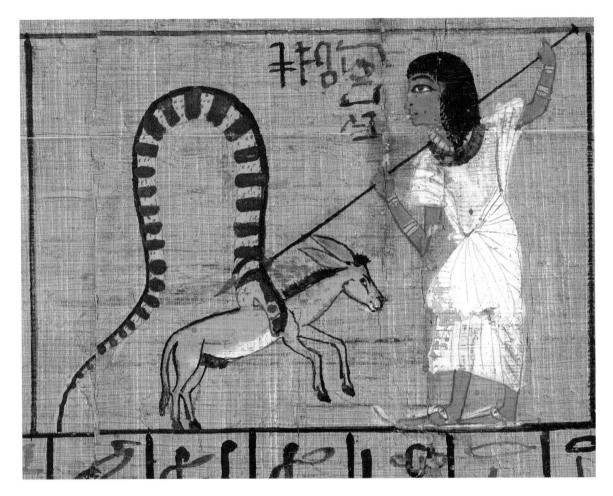

Above *Spell 40. Nakht spears a dangerous snake, one of the enemies of Osiris, which is depicted in the act of swallowing an ass. Papyrus of Nakht.*

Opposite *Spell 36. Nakht drives away the* apshai-*insect, a beetle-like creature. The threat it posed is not explained, but the spell may have been intended to protect the mummy from beetles which fed on carrion. Papyrus of Nakht.*

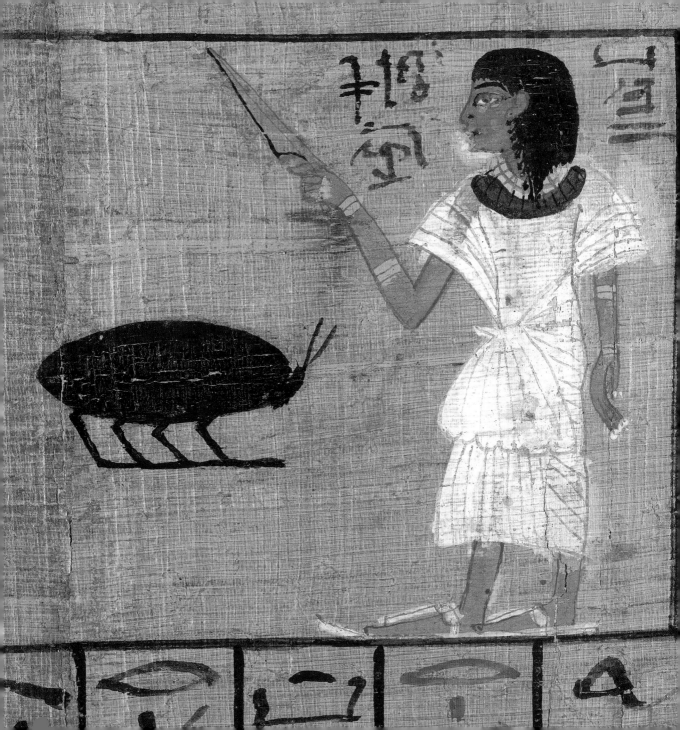

Spell 153A. Nakht escapes being caught in the clap-net set by the divine fishermen who sought to trap those unworthy of entering the afterlife. Papyrus of Nakht.

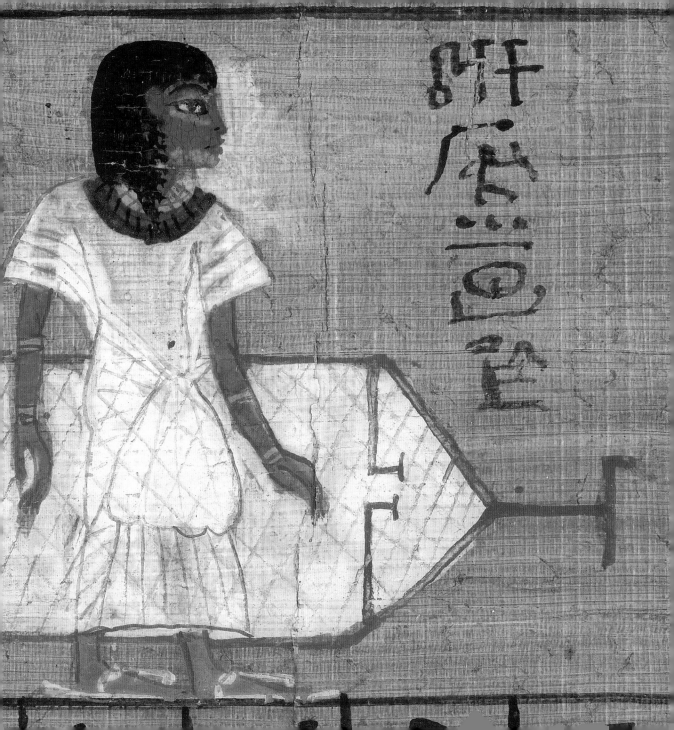

Spell 182. Minor deities painted on the coffin of Horaawesheb. The knives, lizards and snakes which they hold express their power over malevolent forces and their ability to protect the dead person from dangers in the Netherworld.

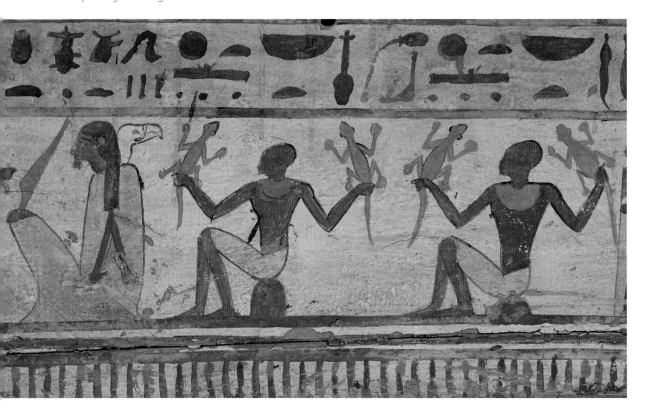

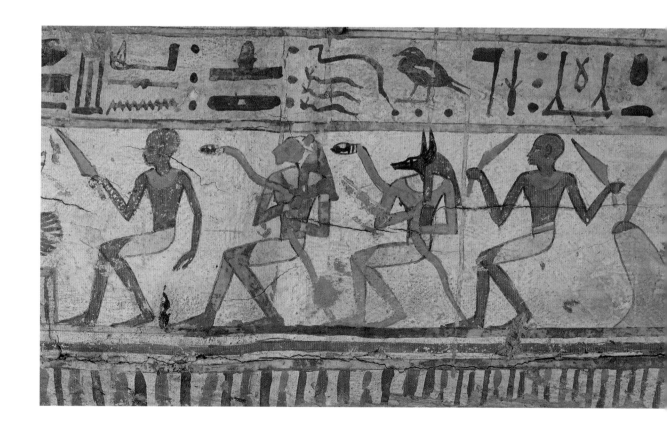

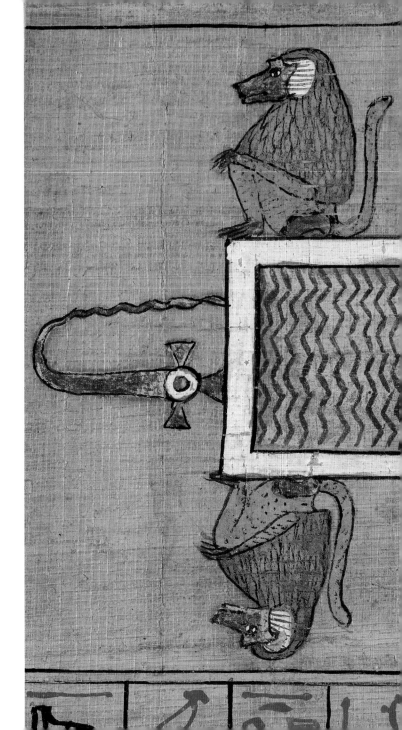

Spell 126. The Lake of Fire, a region of the Netherworld, surrounded by baboons and flaming torches. The waters of the lake turned into food to nourish the righteous but became a mass of deadly flames when approached by the wicked. Papyrus of Ani.

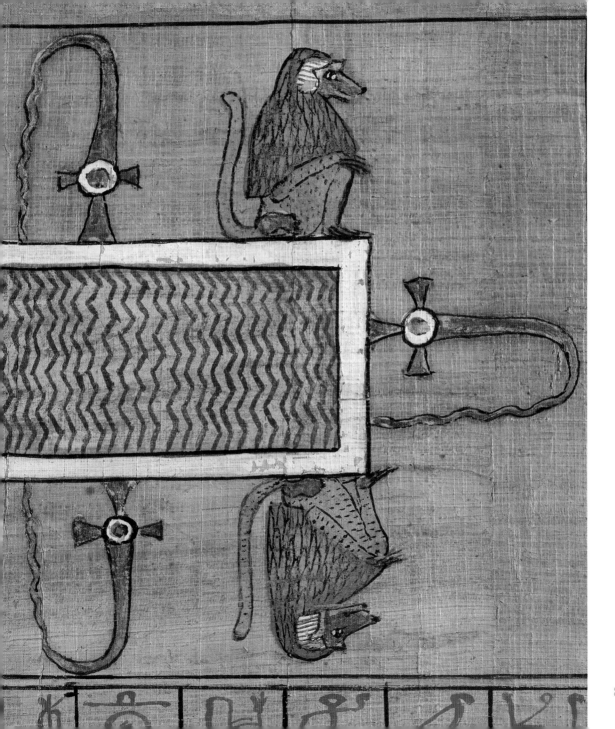

6

Weighed in the Balance

AT some unspecified place within the Netherworld was the hall where the dead underwent judgement by the gods to determine whether or not they deserved to be admitted to the afterlife. This judgement took the form of a review of their past life and an assessment of their conduct to establish whether the individual had lived in accordance with the principles of Maat, the Egyptian concept of order, right and truth. This was the first clear appearance of the notion that a person's moral character could influence their fate after death.

Spells 125 and 30B in the Book of the Dead provided the deceased with full details of what would happen in the judgement hall. First he must answer questions to show that he was worthy to enter, and then he had to convince the gods that he was pure and free from sin. Inside the hall were forty-two assessors. The deceased had to approach each in turn and address them in correct form. They had strange names such as 'Swallower of shadows, who came forth from the cavern' and 'Blood-eater, who came forth from the slaughter-block'. Before each god he declared himself innocent of a specific sin. These included offences against persons and property, such as killing, lying and robbery, and also infringements of religious duty. The latter indicate that these texts had a basis in cult practices, where priests had to prove their purity before they could enter the temple.

At the culmination of the trial the gods examined the dead man's heart, the organ which the Egyptians regarded as the seat of the mind. The depictions show it being weighed in a balance by the god Anubis against an image of Maat.

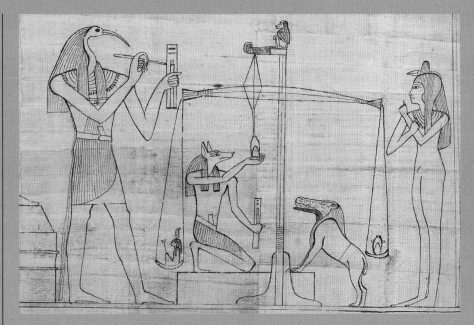

Thoth, Anubis and the Devourer at the weighing of the heart of Nesitanebisheru. Papyrus of Nesitanebisheru.

A correct balance signified a life free from sin, but this alone did not suffice. The heart contained knowledge of all its owner's deeds, good and bad, and at this anxious moment there was great fear that it might betray the owner by revealing his sins to the gods. Spell 30B, usually inscribed on an amulet called the heart scarab, averted this, commanding the heart not to testify against its owner. The penalty of failing the test was to be handed over to a monster called the Devourer, or the Devourer of the Damned, which is often shown crouching by the scales. This creature was a hybrid of three animals – crocodile, lion and hippopotamus. Its role was to act as executioner of the condemned.

In the Book of the Dead the deceased is always shown as being vindicated at the judgement, since this was the desired outcome. The ibis-headed Thoth, the scribe of the gods, is seen writing down the result. The dead man's heart is restored to him and he is led forward and presented to Osiris.

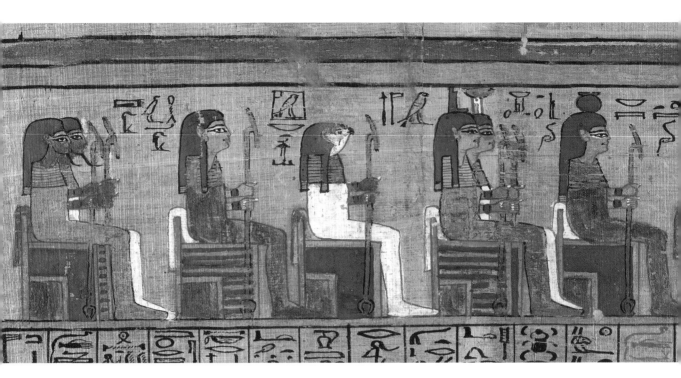

*Spell 125. A series of major deities who sit as witnesses
to the judgement of Ani. They include Ra, Atum, Shu,
Tefnut, Geb, Nut, Isis, Nephthys, Horus, Hathor, Hu and
Sia. These are the regular occupants of the sun-god's
celestial boat. Papyrus of Ani.*

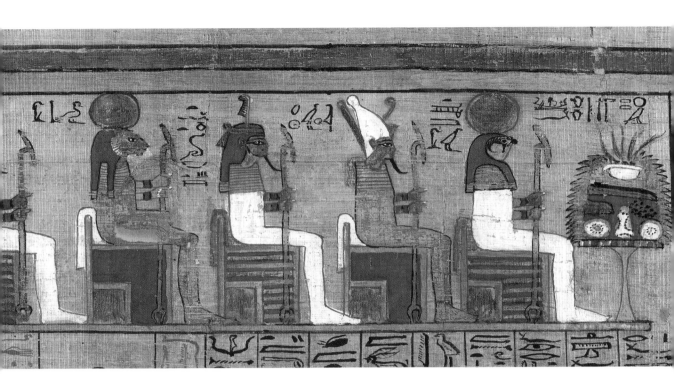

Below *Spell 125. Pasenhor, accompanied by Horus, kneels before the enthroned Osiris, who judges him. He is accompanied by the Sons of Horus and a giant guardian snake. Coffin of Pasenhor.*

Opposite *Spell 125. Osiris, Lord of Eternity, enthroned within a shrine in the hall of judgement, and attended by his sisters Isis and Nephthys. The four Sons of Horus stand facing him on a large lotus flower. Papyrus of Ani.*

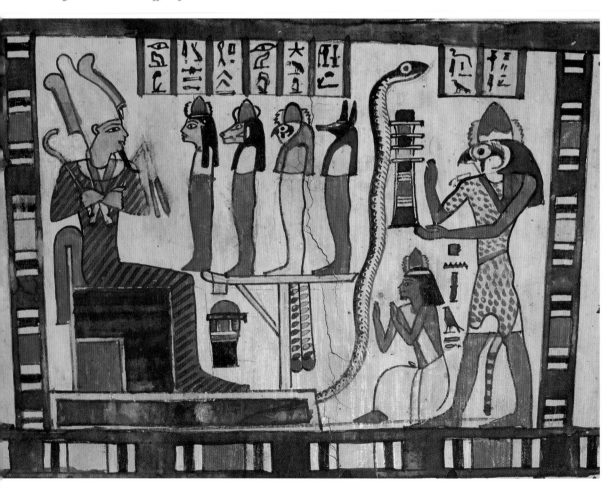

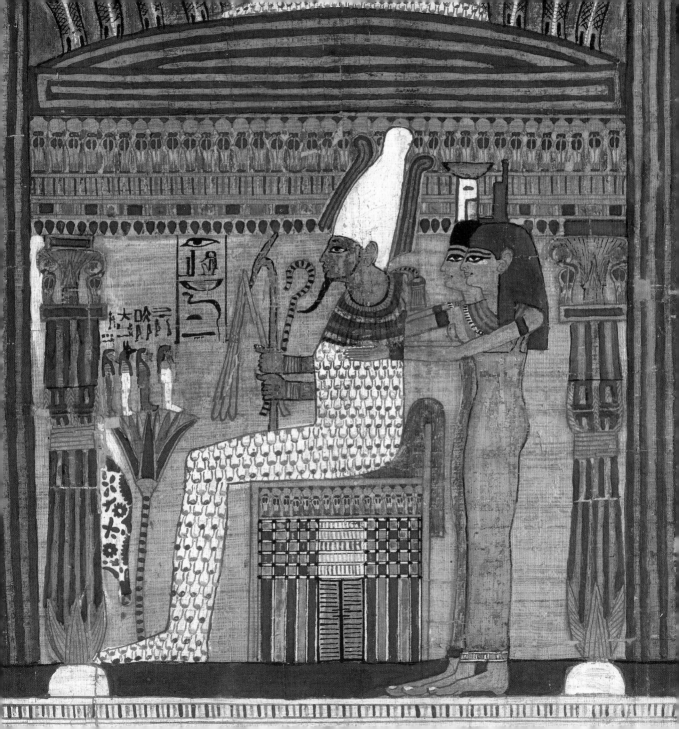

Inscriptions on the coffin of Pasenhor. They include extracts from spell 125, in which the dead man declares himself innocent of a series of forty-two sins.

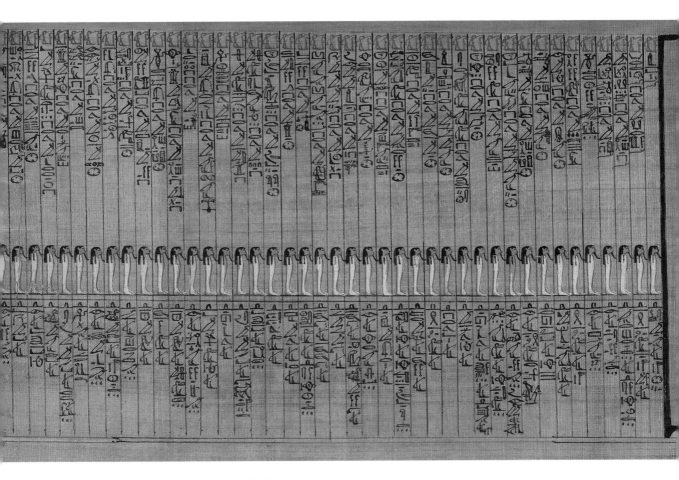

Spell 125. The forty-two assessors in the hall of judgement.
The texts give the words which the dead person must
speak, naming each god and denying his guilt of a specific
act of wrongdoing. Papyrus of Nu.

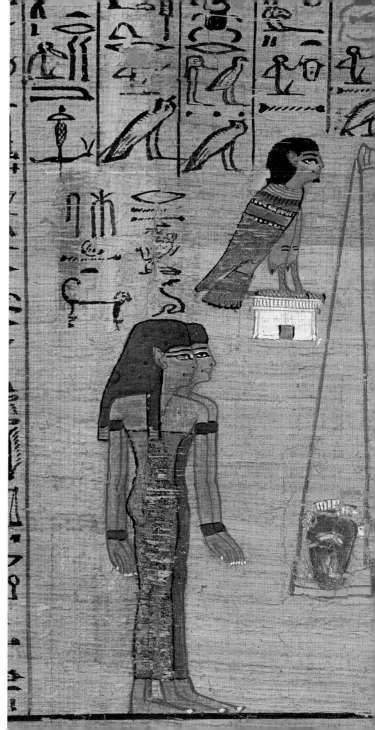

Spell 125, Anubis weighs the heart of Ani against the feather representing Maat, the concept of Right and Truth. Ani's ba-spirit watches, and the judgement is witnessed by Shai ('Destiny') and the birth-goddesses Meskhenet and Renenet. Papyrus of Ani.

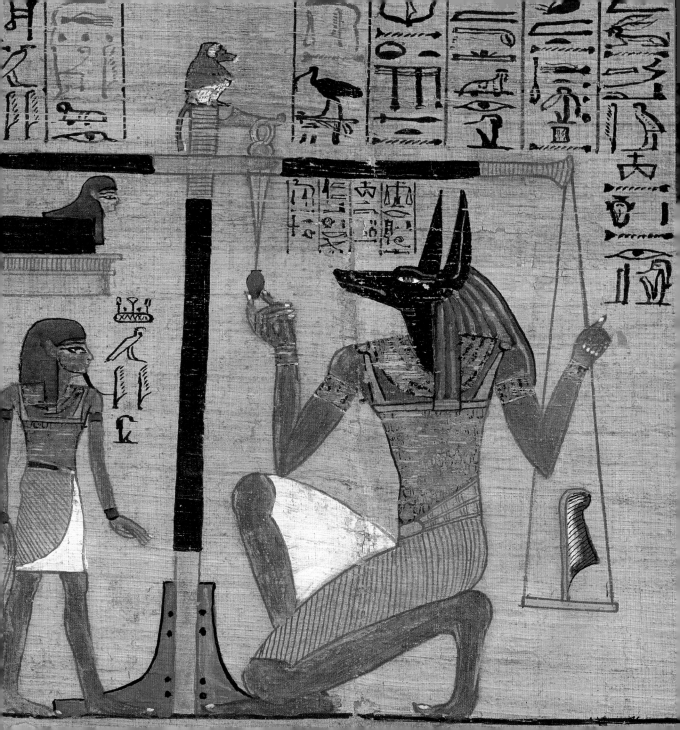

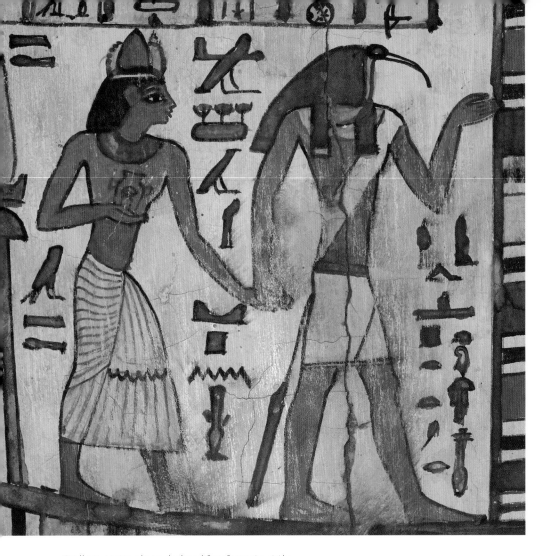

Spell 125. Having been declared free from sin at the judgement, Pasenhor receives his heart, which he holds in his right hand. He is led towards Osiris by Thoth, before whom is written 'Coming in peace to the Beautiful West.' Coffin of Pasenhor.

Opposite *A heart-scarab amulet in the form of the dung beetle. The inscription (spell 30B) commands the heart not to testify against its owner at the judgement.*

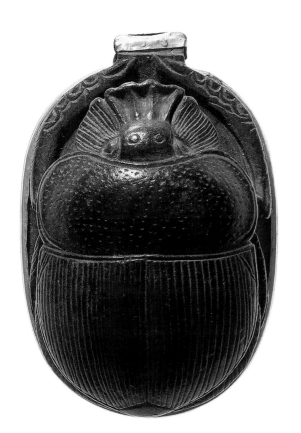

'O my heart of my mother … Do not stand up as a witness against me, do not be opposed to me in the tribunal, do not be hostile to me in the presence of the Keeper of the Balance!'

(Spell 30B)

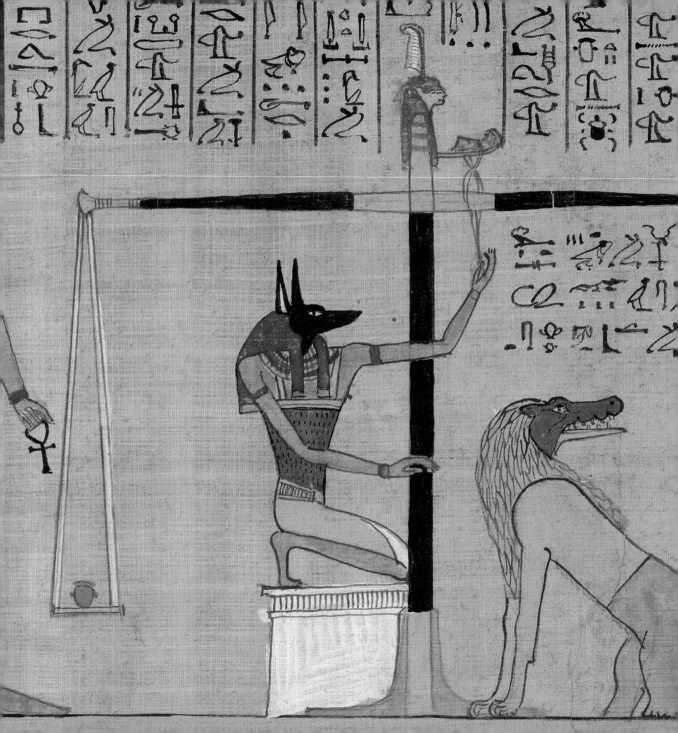

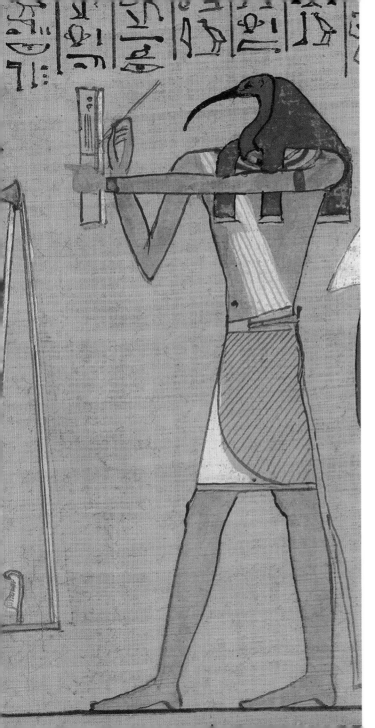

'I have judged the heart of the deceased, and his soul stands as a witness for him. His deeds are righteous in the great balance, and no sin has been found in him.'

(The declaration of Thoth)

Spells 125 and 30B. Hunefer's heart is weighed by Anubis, while Thoth records the result. The 'Devourer' waits to swallow the heart if Hunefer should be declared undeserving of the afterlife. The monster is described in the text above: 'The Devourer of the Damned: her front is a crocodile, her rear a hippopotamus, her middle a lion.' Papyrus of Hunefer.

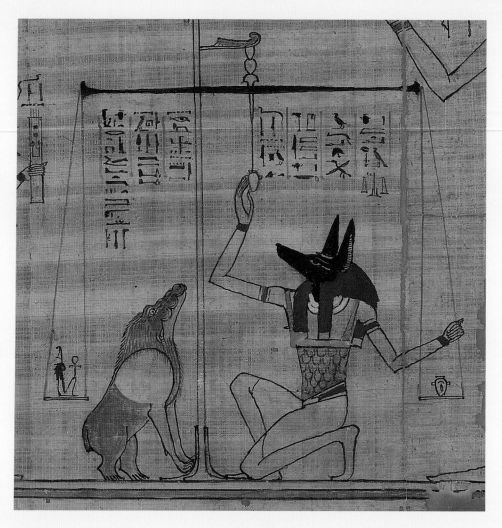

Spell 125. Alternative images of the Devourer. In the papyrus of Anhai (above) she is small in scale and lurks directly beneath the balance. The artist of the papyrus of Ani (opposite) has positioned her behind Thoth and has envisaged her as a larger creature. The speckled markings on her forepart suggest a leopard or cheetah rather than a lion.

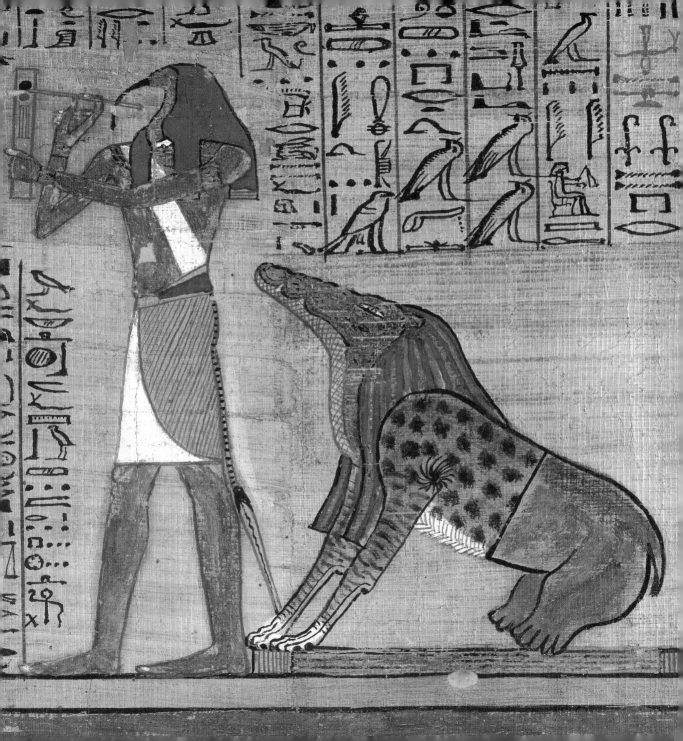

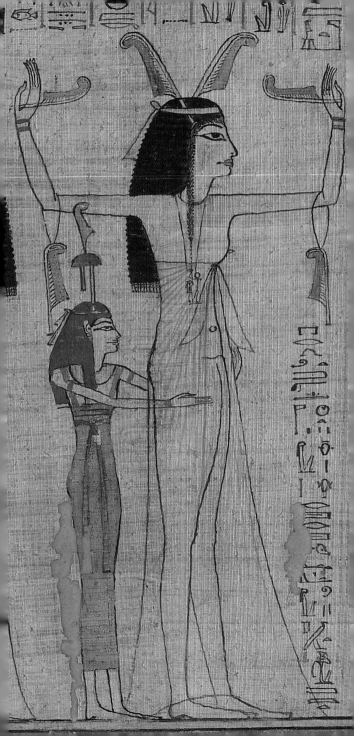

'Coming forth in the presence of the Nine Gods, my heart rejoicing and my arms laden with Truth.'

(Caption to the figure of Anhai)

Opposite *Spell 125. Anhai raises her arms in jubilation at having passed safely through the judgement. She is adorned with feathers symbolizing Maat, and wears an amulet in the shape of the goddess on her breast. The Goddess of the West, a form of Hathor, embraces her. Papyrus of Anhai.*

Overleaf *One of the last depictions of the judgement, in the papyrus of Kerasher (first century BC), shows the dead man watching as Horus and Anubis weigh his heart. Thoth records the outcome at left, and on the right Kerasher rejoices at his vindication, accompanied by the goddess Maat-Hathor, whose face is turned away.*

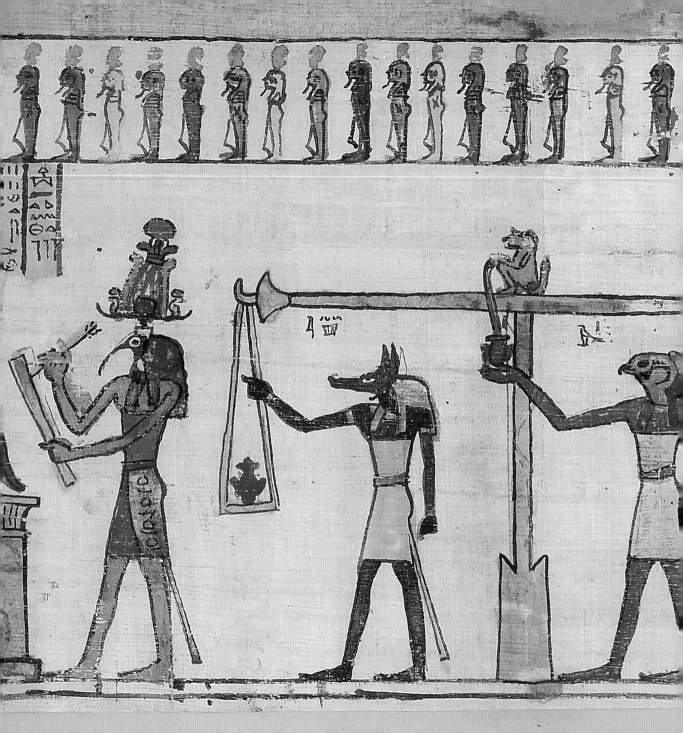

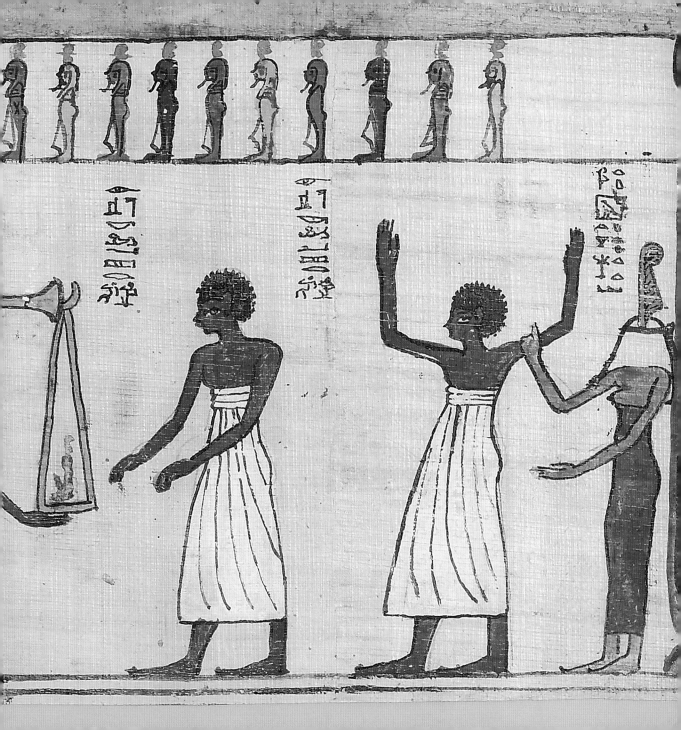

7

Eternal Paradise

BECAUSE of the open and receptive character of Egyptian religious thinking, different conceptions of the afterlife arose over thousands of years and were adopted in spite of their apparent inconsistencies. The spells in the Book of the Dead clearly reflect this long process of evolution and compilation, for they enshrine several different ideas about the nature of the afterlife. The Book of the Dead does not seek to guide the deceased to one specific goal; its spells provided help in following several different paths.

The fundamental idea was that the dead would enjoy the freedom to travel – to leave the tomb by day and to move unhindered through the sky or the Duat. Many spells focus on the dead person's participation in the cyclical passage of the sun-god, enabling him to go aboard the god's boat and to be accepted into the company of deities who formed his entourage. Each night the journey led through the Netherworld, where the sun-god battled against the chaos-serpent Apep, a struggle in which the deceased might also take part. During this journey the sun-god and Osiris were briefly united and rejuvenated, just as were the *ba* and mummy of the mortal deceased. After rejuvenation came the renewal of life at the sunrise, when hymns of praise to Ra were recited – examples of which regularly found a place in Book of the Dead papyri. There were also many spells which gave the dead person access to the kingdom of Osiris; having passed through many challenges including the judgement, he entered the following of the god and became in some sense identified with him.

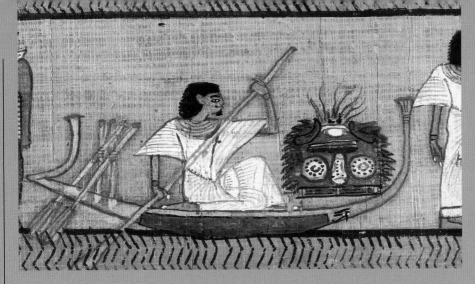

Ani rows a boat in the Field of Reeds. Papyrus of Ani.

But the afterlife would not be confined to an austere communion with the gods, for the Egyptians also envisaged a kind of paradise, a return to the familiar world they had left behind – blessed with its comforts but freed from its troubles. This was called the Field of Offerings or the Field of Reeds; its actual location, in the sky or within the Netherworld, is not clearly specified but several spells in the Book of Dead describe it and the vignette of spell 110 illustrates the landscape, which resembles that of the Nile or the Delta marshes. Areas of dry land are divided up by waterways; here corn and flax grow, and settlements flourish, where gods and the blessed dead dwell. The dead arrived in this 'Elysian Field' in the sun-god's boat. There they planted and harvested their crops, which grew to fantastic heights, and here they met the gods and were reunited with family members long-dead.

The Field of Reeds was a place of rest and abundance, and although manual work was needed to prepare the ground for cultivation and to irrigate the banks, the deceased could avoid these labours by means of spell 6. The words activated figurines (shabtis) of the dead person which were placed in the tomb to act as his substitutes.

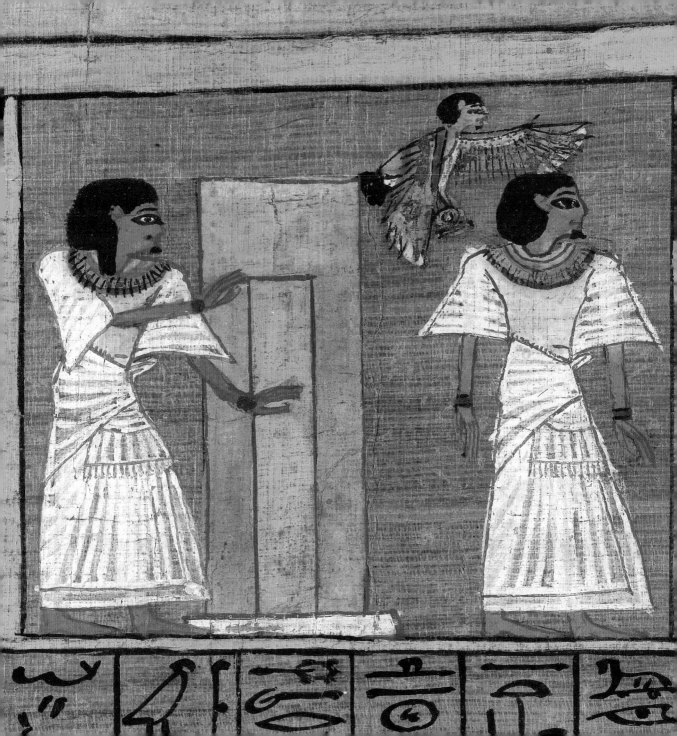

'May he grant that I see
the sun-disc and behold the
moon unceasingly every
day; may my soul go forth to
travel to every place which
it desires; may my name be
called out, may it be found
at the board of offerings;
may there be given to me
loaves in the Presence like
the Followers of Horus...'

(Spell 15, papyrus of Ani)

Spell 92. Ani opens the door of his tomb to enable
his spirit to leave and re-enter it freely. At right
he appears again accompanied by his ba *in bird-*
form, 'coming forth by day'. Papyrus of Ani.

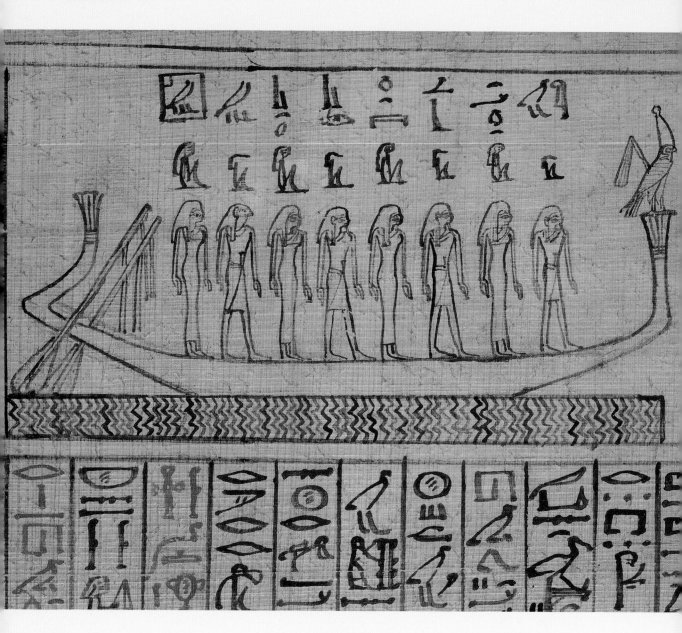

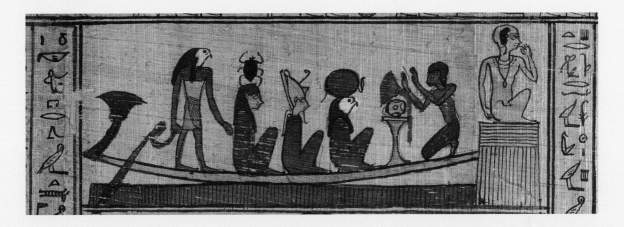

Spell 16. The dead man, Hor, kneels in the solar-boat, raising his hands in worship before the sun-god who appears in three forms – Ra, Atum and Khepri, the daytime, evening and morning sun respectively. The rudder is controlled by Horus, and he appears again, squatting at the prow in the form of the child-god Harpocrates. Papyrus of Hor.

Opposite *Spell 134. The sun-god's boat, which the deceased wished to enter. An ancient note to this spell explains that it would ensure that he 'will voyage and be with Ra every day in every place he desires to travel.' Papyrus of Nebseny.*

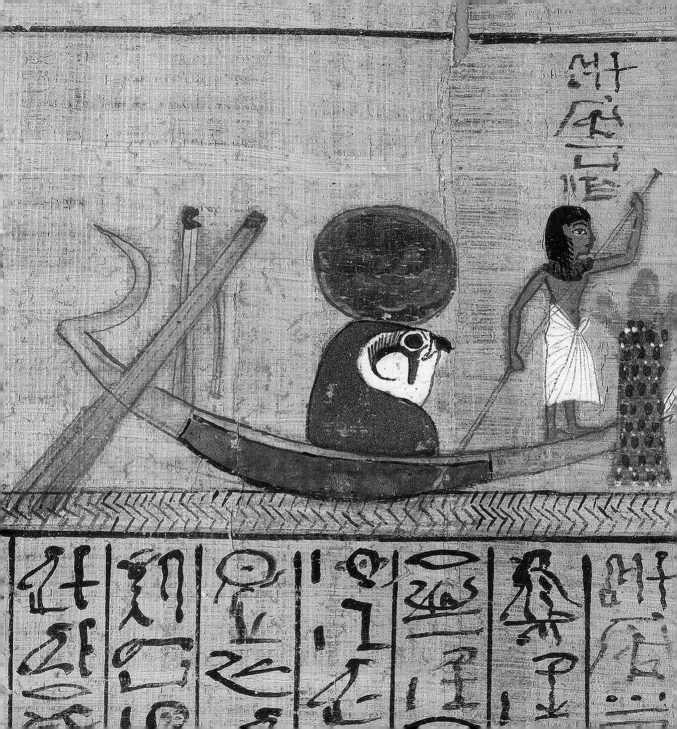

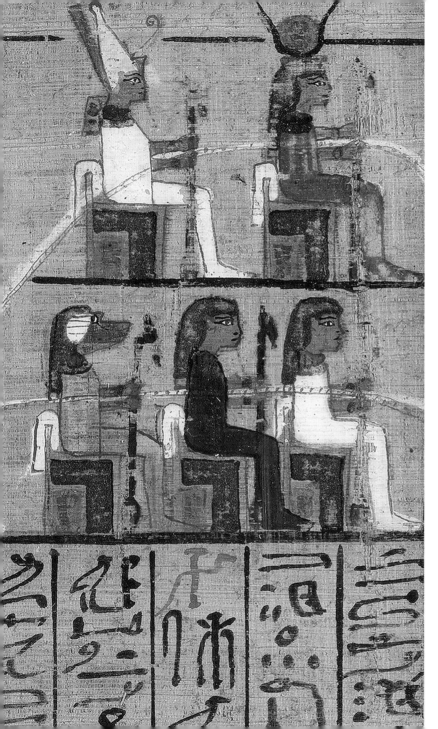

Spell 136B. Nakht stands in the sun-god's boat, piloting it with a pole, while a group of seated gods (at right) haul on ropes to move it forward. The sun-god himself is represented by a large falcon-head wearing the solar-disc as a headdress. Papyrus of Nakht.

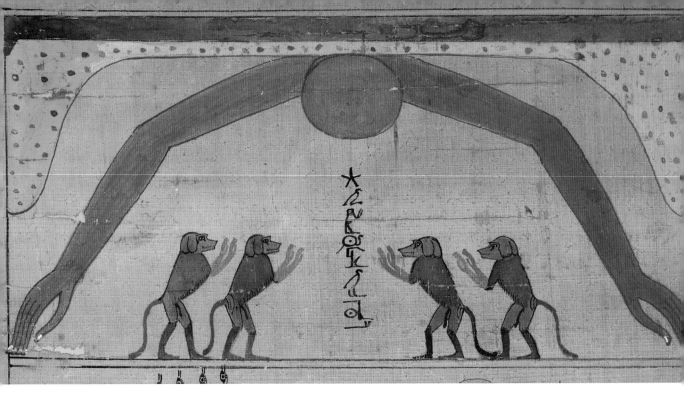

Spell 16. A depiction of the sunrise. The solar-disc emerges from the horizon (shown as a sandy desert valley). Its appearance is greeted by baboons, animals which were traditionally regarded as adorers of the sun because they became active at dawn. Papyrus of Userhat.

Opposite *Spell 16. An alternative view of the sunrise. The sun-god as a falcon rises from the Netherworld realm of Osiris, in which he has journeyed through the night. The sky is shown schematically as a curved blue vault, while the baboons leap and clap their paws in adulation. Papyrus of Hunefer.*

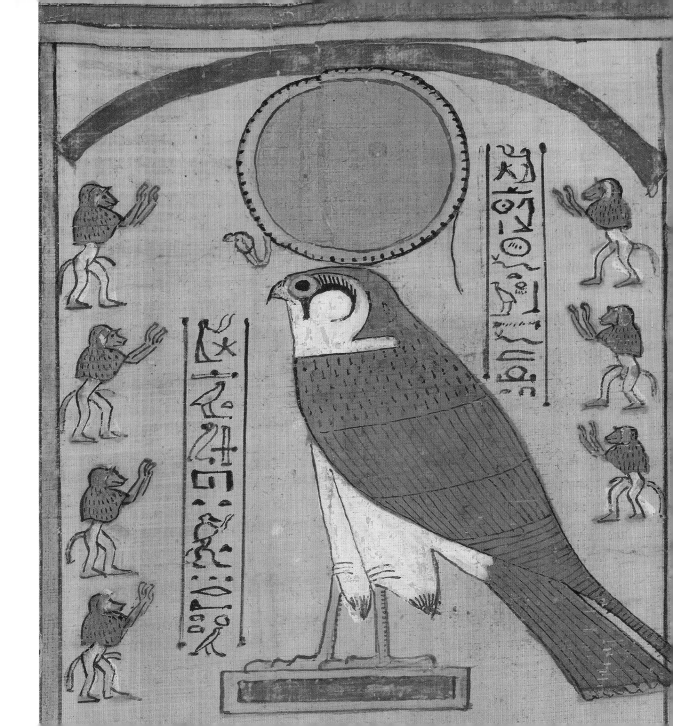

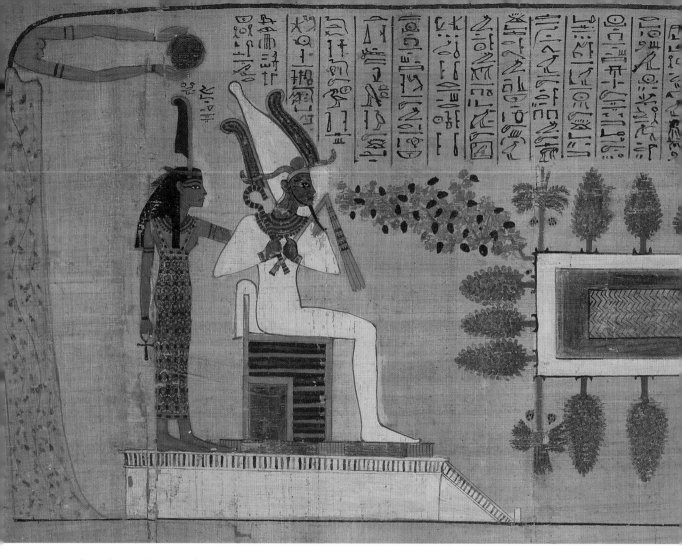

Spell 15. A hymn of praise to the sun-god is illustrated with an unusual scene in which Nakht and his wife adore Osiris, who sits before the western horizon. The setting sun is received into the hands of the sky-goddess Nut. Depictions of Nakht's house and his garden, with a tree-lined pool, suggest the comforts of the earthly life which the couple perhaps hope to regain in the Netherworld. Papyrus of Nakht.

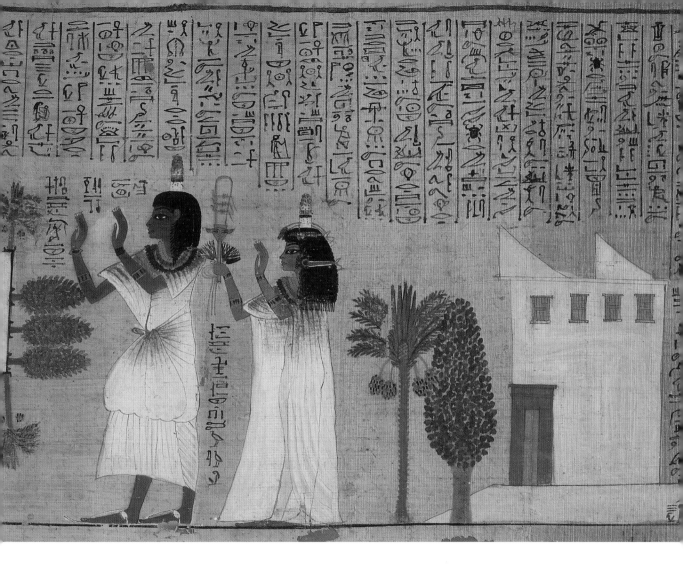

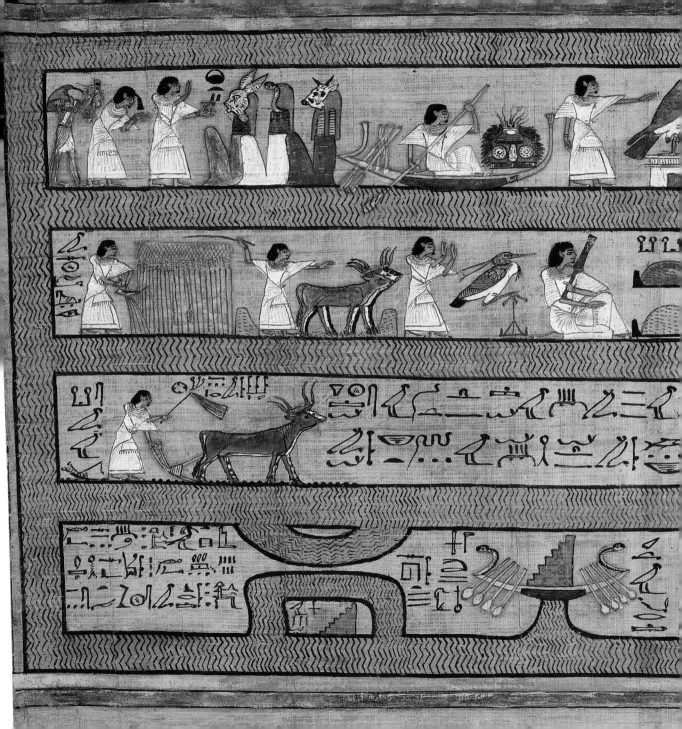

Spell 110. The Field of Reeds. This mythical landscape, the ultimate goal of the dead, resembled that of the Nile valley and Delta. Ani arrives at paradise in the sun-god's boat (bottom). Above, he ploughs the earth, harvests and threshes his crops and provides the spirits of the blessed dead with food. At the top, he travels by boat about the abundant fields and enters the company of the gods. Papyrus of Ani.

Overleaf *Detail of the Field of Reeds from the papyrus of Ani.*

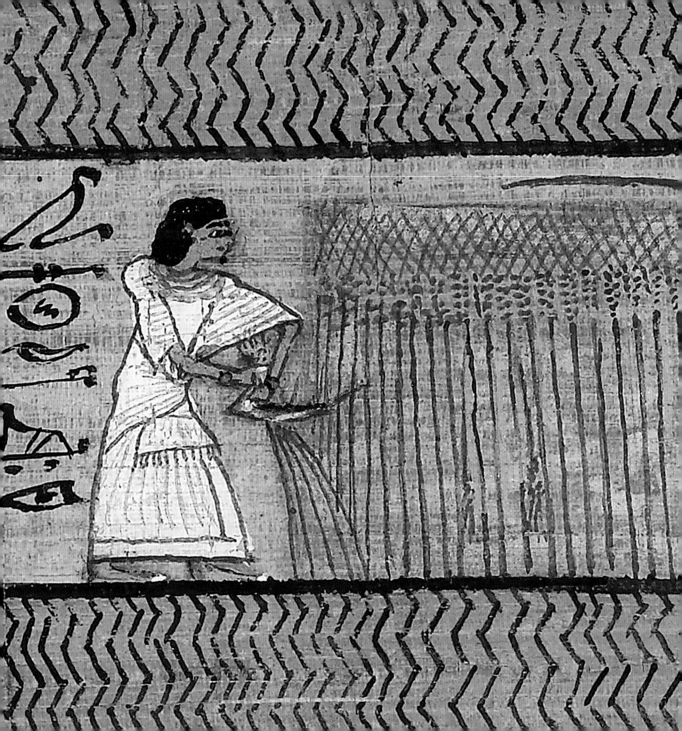

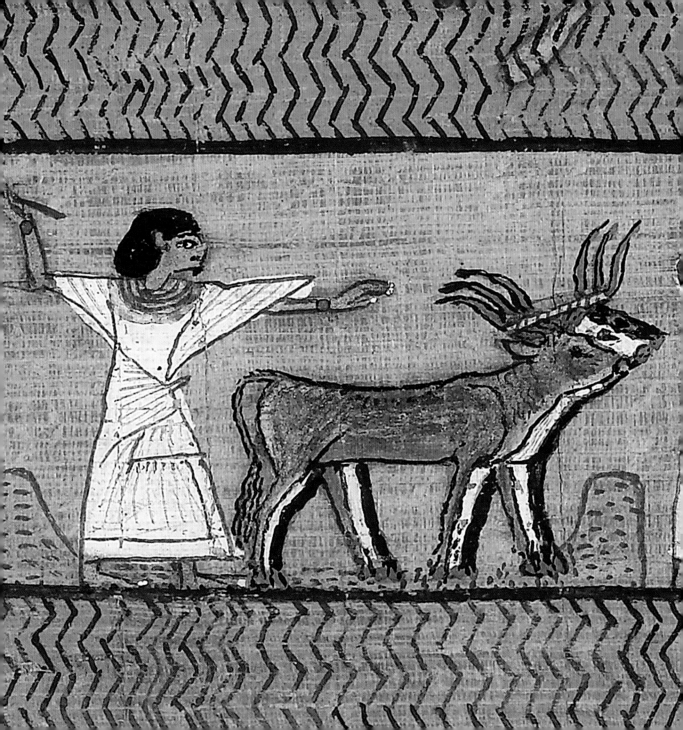

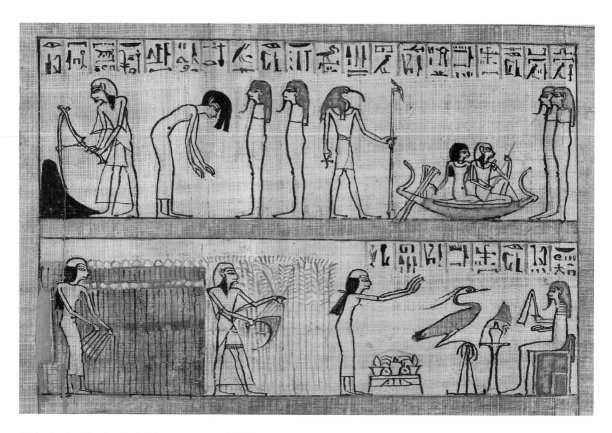

In the Book of the Dead of Anhai, a woman of high status, the afterlife in the Field of Reeds follows the same pattern as that in Ani's papyrus. But some of the tasks, such as harvesting grain with a sickle and digging the earth, are performed by Anhai's husband Nebsumenu. The two of them also share the boat which conveys them from place to place. Instead of the gods whom Ani worships, this section shows Anhai bowing before mummified figures, one of whom is named as her mother: the Field of Reeds was also the place of joyful reunion with the departed members of one's family.

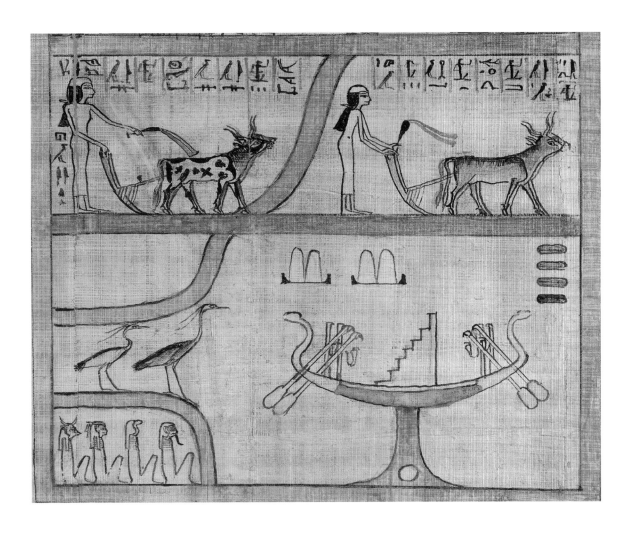

Right *Spell 6. As in the world of the living, the dead in the Field of Reeds could be summoned by the gods to perform manual labour. Spell 6 activated a statuette called a shabti, which would answer the call to work on the deceased's behalf. These figurines represent the owner in mummy-shape holding agricultural tools. The words of the spell were often inscribed on the body.*

Far right *As time passed, wealthy Egyptians equipped themselves with larger and larger numbers of shabtis. These were sometimes stored in wooden boxes shaped like shrines, which were decorated with painted images of the dead person adoring gods and goddesses.*

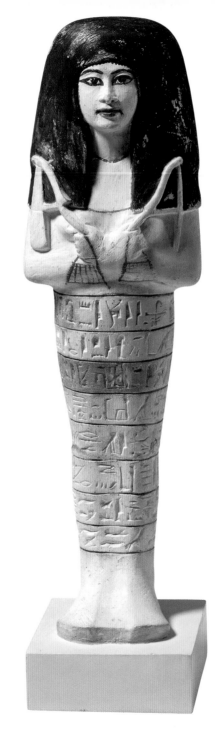

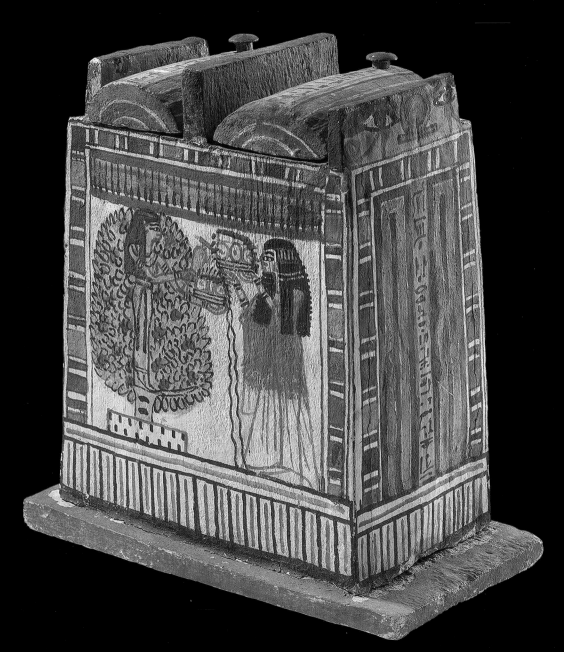

125

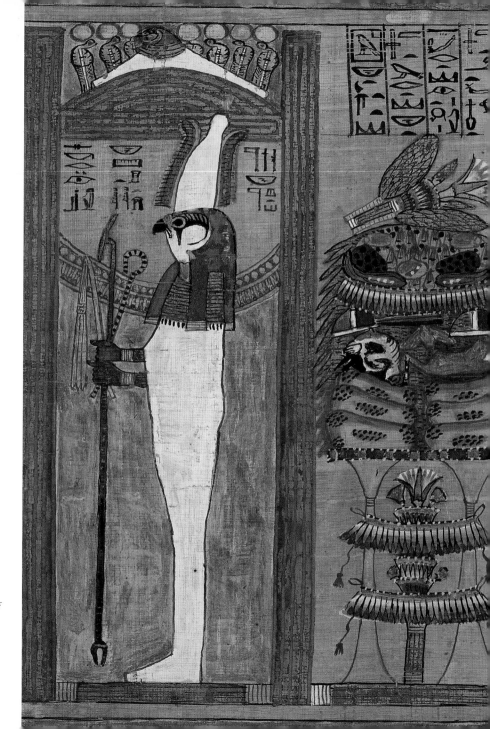

Spells 185 and 186. These large illustrations mark the end of Ani's Book of the Dead. At the left stands the god Sokar-Osiris, and to his right is Ipet, the hippopotamus goddess of birth, who holds a torch to drive away Seth. The roll ends with an image of Ani's tomb beneath the mountain slopes on the west bank of the Nile, over which the goddess Hathor in cow-form watches protectively, screened by waving stalks of the papyrus plant. Papyrus of Ani.

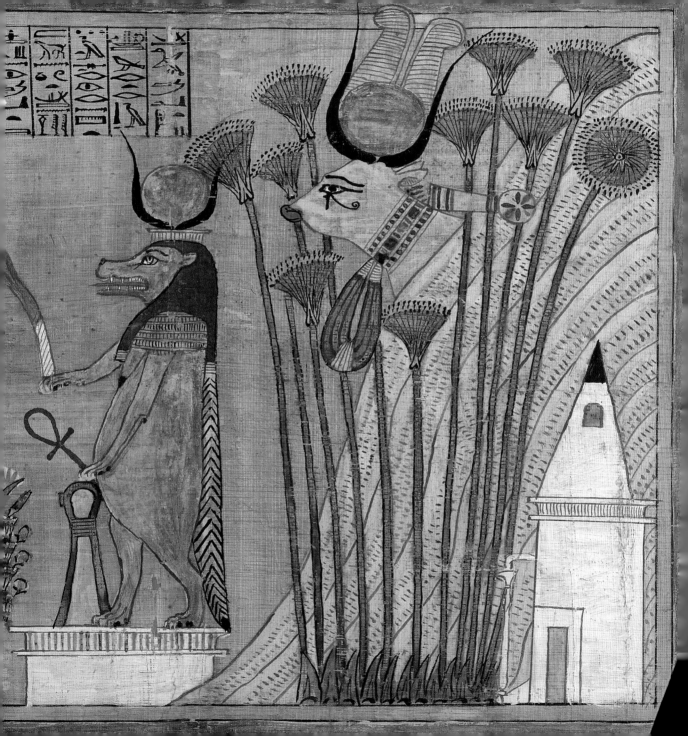

Further Reading

R. O. Faulkner, *The Ancient Egyptian Book of the Dead*, C. Andrews (ed.). London 1985 (rev. edn), repr. 2010.

B. Kemp, *How to Read the Egyptian Book of the Dead*. London 2007.

Richard Parkinson, *The Complete Book of the Dead of Hunefer: A Pullout Papyrus*. London 2010.

John H. Taylor, *Journey through the Afterlife: Ancient Egyptian Book of the Dead*, London 2010.

Illustration References

The details of the British Museum papyri and objects illustrated in this book are as follows:

Papyrus of Anhai, EA 10472, 20th Dynasty, *c.* 1100 BC.

Papyrus of Ani, EA 10470, 19th Dynasty, *c.* 1275 BC.

Papyrus of Bakenmut, EA 10478, 19th Dynasty, *c.* 1250 BC

Papyrus of Hor, EA 10479, late first century BC.

Papyrus of Hunefer, EA 9901, 19th Dynasty, *c.* 1280 BC.

Papyrus of Kerasher, EA 9995, reign of Augustus, late first century BC.

Papyrus of Muthetepty, EA 10010, 21st Dynasty, *c.* 1050 BC.

Papyrus of Nakht, EA 10471, Late 18th or early 19th Dynasty, *c.* 1350–1290 BC

Papyrus of Nebseny, EA 9900, 18th Dynasty, c. 1400 BC

Papyrus of Nesitanebisheru, EA 10554, Late 21st or early 22nd Dynasty, *c.* 950–930 BC.

Papyrus of Nodjmet, EA 10541, Early 21st Dynasty, *c.* 1050 BC.

Papyrus of Nu, EA 10477, 18th Dynasty, *c.* 1400 BC.

Papyrus of Userhat, EA 10009, 18th Dynasty, *c.* 1450 BC.

p. 6 unopened papyrus roll, Third Intermediate Period (*c.* 1069–664 BC) or later, EA 10748.

pp. 27, 90, 92 and 96 coffin of Pasenhor, painted wood, late 22nd or early 25th Dynasty (*c.* 750–720 BC), EA 24906.

p. 32 magic brick with faience *djed* pillar, 19th Dynasty (*c.* 1250 BC), EA 41547.

p. 37 outer coffin of Henutmehyt, painted and gilded wood, 19th Dynasty (*c.* 1250 BC), EA 48001.

p. 39 mummy-mask, painted and gilded cartonnage, Ptolemaic/Roman Period (first century BC–first century AD), EA 29472.

p. 41 amulets: *djed* pillar, blue glass, 18th–19th Dynasties (*c.* 1550–1186 BC), EA 20623; Isis knot, red jasper, New Kingdom (*c.* 1550–1069 BC), EA 20624; heart, basalt, New Kingdom (*c.* 1550–1069 BC), EA 24740; headrest, haematite, 26th Dynasty (*c.* 664–525 BC), EA 20647.

p. 59 coffin of Besenmut, painted wood, late 25th to early 26th Dynasties (*c.* 650 BC), EA 22940.

pp. 75 and 82–3 coffin of Horaawesheb, painted wood, 22nd Dynasty (*c.* 900 BC), EA 6666.

p. 97 heart-scarab amulet, basalt and gold, 18th–19th Dynasties (*c.* 1400–1200 BC), EA 29626.

p. 124 shabti figure, painted limestone, 19th Dynasty (*c.* 1295–1186 BC), EA 24428.

p. 125 box for shabtis of Henutmehyt, painted wood, 19th Dynasty (*c.* 1250 BC), EA 41549.